IMAGES
of America

GLOUCESTER
COUNTY

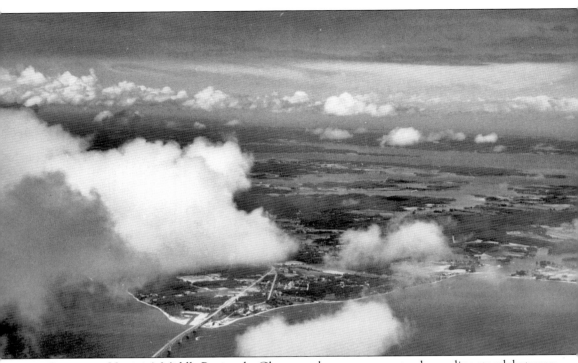

On eastern Virginia's Middle Peninsula, Gloucester becomes a county along a line struck between the Dragon Run and Poropotank Creek. From there, nearly 250 square miles of gentle knolls flow through from northwest to southeast until the land breaks along a perimeter of bluffs. All around, peninsulas and necks that look like fingers and toes love nothing better than to soak in the water. Along more than 300 miles of Piankatank, Mobjack, and York shoreline, slow tidal waves from the Chesapeake Bay baste the county twice a day in a saltwater marinade. (Courtesy Walter G. Becknell.)

ON THE COVER: Between 1900 and 1930, Herman Hollerith Jr. captured scenes of wharfs, boats, and waterfront lifestyles around the Mobjack Bay. Gloucester's "Land of the Life Worth Living" motto comes from this era, when the words were used to promote the sale of land and homes that had fallen into disuse and decay following the Civil War. This photograph of Roane's Wharf was taken in 1908. (Courtesy Herman Hollerith Jr. Collection, Chesapeake Bay Maritime Museum.)

IMAGES
of America

GLOUCESTER
COUNTY

Sara E. Lewis

ARCADIA
PUBLISHING

Published by Arcadia Publishing
Charleston SC, Chicago IL, Portsmouth NH, San Francisco CA

Printed in the United States of America

Library of Congress Catalog Card Number: 2006922940

For all general information contact Arcadia Publishing at:
Telephone 843-853-2070
Fax 843-853-0044
E-mail sales@arcadiapublishing.com
For customer service and orders:
Toll-Free 1-888-313-2665

Visit us on the Internet at www.arcadiapublishing.com

*Dedicated to the people of Gloucester: those who shaped its past
and those who care about its future*

"*The county of Gloucester in which we live, is . . . classic ground; rendered so by events
which have transpired within its borders, the narrative . . . of which, would furnish a volume
full of interest to our own people and to every student of Virginia history.*"
—Gen. William B. Taliaferro, "*A Few Things about Our County,*"
William and Mary Quarterly

"*Here it is that I passed my boyhood and here I have always made my home.*"
—Thomas C. Walker, The Honey-Pod Tree

CONTENTS

ACKNOWLEDGMENTS

As I have worked on this publication, my family and roots have held me close. My parents, F. Raymond and Mary Belle Lewis, and older sister, Susan Dutton, and her family, have lived most of their lives in Gloucester County, Virginia. Although I have lived "across the river" since the 1970s, Gloucester is the home of my heart. We are proud of our county and enjoy close ties.

Soon after I began work on this book, Hillary Hicks of the Rosewell Foundation put me in touch with William L. Brockner of Mathews, who had purchased several "orphaned" photograph albums. The albums belonged to the youngest daughter of Dr. Henry Wythe Tabb (1791–1864) and Ellen Foster Tabb (1828–1858) of Auburn, Susie Vanderpoel Tabb Sanders (1856–1932), and her son, Vanbibber Tabb Sanders (1892–1964). Mr. Brockner has kindly allowed these photographs to be used throughout the book.

Elsa Cooke Verbyla, editor of the *Gloucester-Mathews Gazette-Journal*, has graciously opened the newspaper's files to me, providing an important source of illustrations. She has cheerfully provided assistance and space for my research.

As I worked on this book, I discovered new roads and new friends in parts of the county I had never visited as a child. I am thankful for the time, photographs, and information contributed to this effort by Laura Hargis Baxter, Walter G. Becknell, Mary Bright, Lee Brown, Pat Burke Carlton and C. David Burke, Dr. Dorothy Cooke and the members of Bethel Baptist Church, Susan and Mark Dutton, Ellis and Betty Hall, Brent and Becky Heath, William S. Field, Nan Belvin McComber, Cleo Gregory Warren, and Bill and Madelyn Weaver.

Betty Jean Deal, director of the Gloucester Museum of History; Roane Hunt, museum volunteer and editor of the Gloucester Genealogical Society's *Family Tree Searcher*; and William Moormon, museum volunteer, have been generous with their time and knowledge. I thank my readers Betty Jean Deal and Lillian Cox for their insight. I thank my editor, Kathryn Korfonta, for her guidance.

Finally I thank my husband, Kenneth J. Schmidt, for his unerring support and my children, Elizabeth and Lewis Flanary, for their loving interest.

INTRODUCTION

As the age of photography dawned, the 1850 census captured a numerical snapshot of antebellum Gloucester. It depicted 10,509 individuals living in 1,006 family groups inhabiting 1,000 dwellings. The census tallied 573 farms, but other records bring that number into focus: almost all of Gloucester's best property was owned by a handful of large plantation owners.

Gloucester's geography destined sail and steam-powered boats to be the swiftest means of transportation through the 19th and into the 20th century. Travel by foot or on horseback over inland roads was slow and sometimes treacherous, with routes often following long-ago Virginia Indian roads. Post offices and services like blacksmiths' shops and taverns were located at convenient intersections between river landings and farms, such as Hickory Fork and Woods Cross Roads.

There were gristmills, sawmills, and tanneries. Boat building and other maritime activities were important to the economy. Principal occupations listed in the census were oysterman, farmer, laborer, sailor, fisherman, and craftsman. Lore has it that watermen didn't need boats to harvest seafood since fish, shellfish, and crabs were so plentiful that they could be gathered in shallow water.

Some might look back and think of 1850 as long ago, but it is not. It is only since then that we can savor history without difficulty thanks to the magic of photography.

Before this recent age, seas rose and fell for millions of years to deposit Gloucester's land. The soil was made more fertile by the ebb and flow of glaciers. The latest glacial retreat, which continues to send waters inching higher, gave Gloucester its current riverine shoreline.

For thousands of years before the first camera captured the likeness of an inhabitant, people hunted and gathered on this land. Gloucester's earliest human inhabitants came more than 10,000 years ago following herds of bison and other big game. Less than 1,000 years ago, they began to settle around agriculture and in villages. Four to five hundred years ago, when Europeans first began to spy on them, Virginia Indians, coastal Algonquin-speaking tribes mostly united under the principal Powhatan chiefdom, held this area in high regard.

In his *Map of Virginia*, Capt. John Smith described present-day Gloucester. He said that from Jamestown, "Foureteen miles Northward . . . is the river Pamaunke . . . on the North side of this river is Werawcomoco, where their great King inhabited when Captain Smith was delivered him prisoner." Located on the north bank of the Pamunkey Flu (which was renamed the Charles and then the York River), Gloucester was the political seat of the Powhatan Empire, a network of 30 tribes that moved across the coastal plain of Virginia and organized approximately 15,000 people.

Soon after the English settled at Jamestown, disease and strife caused Virginia Indian numbers to plummet. After Europeans and Africans populated the peninsula between the James and York Rivers, the government granted land according to the headright system—50 acres per person—to encourage New World entrepreneurs. The first land patent north of the river was granted in 1639.

With the passage of Virginia Indian massacres and treaties and time, Gloucester was considered safe for settlement by mid-century. Hundreds flocked to settle its rich soil, made easily accessible by its multitude of waterways.

Gloucester County was formed from York County in 1651. The English named the land for Henry, Duke of Gloucester, third son of Charles I. It was divided into four Anglican Church parishes: Abingdon, Ware, Petsworth, and Kingston (later Mathews County). Because the water-infused land attracted wealthy and influential Colonial settlers, Gloucester figured prominently in the history of the colony and the commonwealth of Virginia.

By 1669, the population of Powhatan Indians in Tidewater Virginia had dropped to fewer than 2,000. By 1722, many of the tribes were believed to be extinct. In the meantime, more Englishmen replaced them. They and their indentured servants and slaves came and set to work growing tobacco. When they could pause from the work of living, they could see this place both as an opportunity to reap benefits unavailable to them in the Old World and as a daunting place in a foreign land on the fringe of a frightening wilderness.

It is useful and humbling to step back and keep this big picture in mind. With consideration and respect for these past times and people, we leap forward past Gloucester's plantation years to the Civil War and the photographic age. The story told by the few yet diverse photographs in this book cover a short century and a half, but they exude a past that continues to concern and captivate us today.

Those who come here and those who have lived in Gloucester a long time may see this photographic description of a rural Virginia county between the Civil War and the last decades of the 20th century as hard to imagine beneath what we see growing up around us today. As we rush forward at a 21st-century pace, may this book serve as a place of brief repose. May it give us reason to consider what it is about Gloucester that attracted our ancestors and attracts us to lay claim to this place—to call it home.

One

A Land before Time

During the closing years of the 19th century, a photographer visited Gloucester families—Roanes, Catletts, Taliaferros, and others. When the author first saw some of the similarly dated and composed photographs like the one on the next page, she was overwhelmed by something personal. She imaged the people who stared back at her as having had a conversation with her great-grandfather, Charles Lewis. Perhaps Harvey Roane engaged him to build a boat or perhaps they discussed the Baptist congregation Lewis championed in Mathews.

But what about this land before photography's time? How do we image it? It is not as easy to visualize as our recent past. Facts such as those provided by a census or legends told by elders invite us to guess. Primary documents and drawings help historians piece together information to back their educated assumptions. Archaeological evidence and DNA back conclusions about how people lived and what they looked like in this land before time. For some, Gloucester's heritage is spiritual, an essence that is visible in the faces of people who celebrate 50- and 100-year milestones on land their ancestors called home for thousands more. The deeper we look, listen, and learn, the more accurately we can imagine. There are still many families in Gloucester for whom the imagining is not as hard, because they are descended from two or more lines of Gloucester families of European, African American, or Virginia Indian blood.

Before moving on to look at photographs from our recent past, take a step back to your ancestors' time and look over their shoulders to an age before European exploration and the 17th-century peopling of this land by the previously landless and enslaved. Imagine Virginia's Native Americans, who once saw Gloucester as the capital city of the Powhatan Indians. Think about Gloucester before photography's time, then turn around and step ahead. See the artist sketch the busy harbor at Gloucester Town as it rises while earlier populations retreat. Compare then to now. While you are thinking about these things, try to imagine what Gloucester will look like in 100 or 400 years.

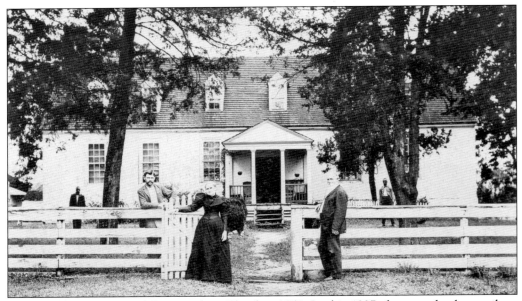

Warner P. Roane married Frances Ann Bland in 1850. In this 1897 photograph, they strike a welcoming pose in front of their home, Mount Prodigal, near Adner. Warner's father, Charles S. Roane, purchased the property about 1820. The couple's son, Harvey B. Roane, probably the man leaning on the fence behind Frances, inherited it. (Courtesy Library of Congress, Prints and Photographs Division, Historic American Buildings Survey, HABS VA,37-GLO.V,3-5.)

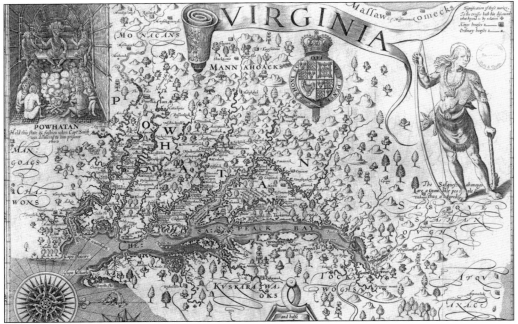

John Smith's map shows the land as English settlers discovered it occupied by Powhatan Indians, whose tribes dominated the coastal plain, in 1607. The principal chiefdom was located at Werowocomoco in present-day Gloucester County. (Courtesy Library of Congress, Geography and Map Division, *Virginia discovered and discribed by Captayn John Smith, 1606.*)

10

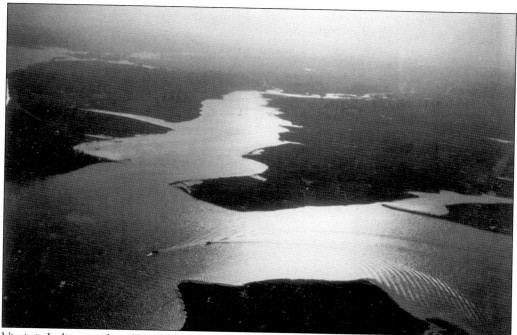

Virginia Indians preferred low-lying necks of land that provided easy access to water for food—shad, sturgeon, oysters, and crabs—and transportation. The rich and sandy soil was ideal for growing beans, squash, and corn. The English clashed with the Virginia Indians from the earliest days as settlers claimed land that was tribal territory. The concept of land ownership was perplexing to the natives, since they considered land to be a fluid resource, like the water and the air—and the game, fish, and birds that moved throughout them. (Courtesy Walter G. Becknell.)

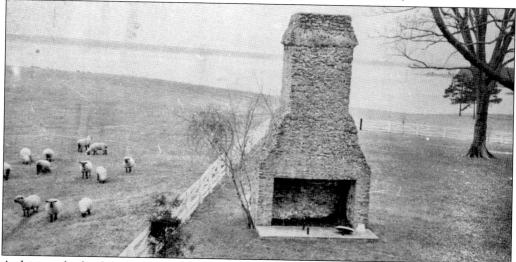

A chimney built of marl is reputed to be all that is left of an "English house" built by John Smith for Chief Powhatan. The Association for the Preservation of Virginia Antiquities refurbished the structure in the 1930s. Recent research has cast this local legend in doubt. Seen here in a photograph taken in 1958, the chimney stands today surrounded by a subdivision. (Courtesy Walter G. Becknell.)

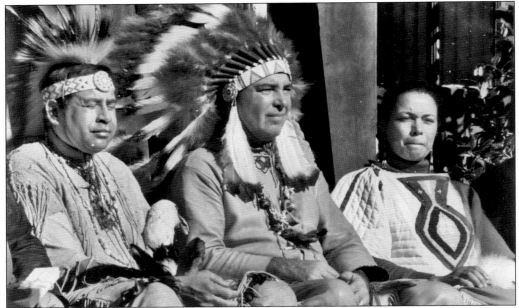

Virginian tribes were represented by Chief Marvin Bradby of the Eastern Chickahominy tribe, Chief William Miles of the Pamunkey, and Judy Fortune of the United Rappahannock tribes during a 1994 ceremony honoring descendants of the Powhatan tribe and Pocahontas. Chief Powhatan's daughter, Pocahontas, is believed to have been present when John Smith was held captive in Werowocomoco. (Courtesy Tidewater Newspapers, Inc.)

The Dragon Swamp makes up Gloucester's northernmost border, and naturalists enjoy the well-preserved area. It evokes imagery from Henry Spelman's 1609–1610 firsthand account of Virginia, where he said, "The country is full of wood . . . and water they have plentiful . . . there be in this country Lions, Bears, wolves, foxes, musk cats, Hares . . . great store of fowl . . . fish in abundance." (Courtesy Tidewater Newspapers, Inc.)

12

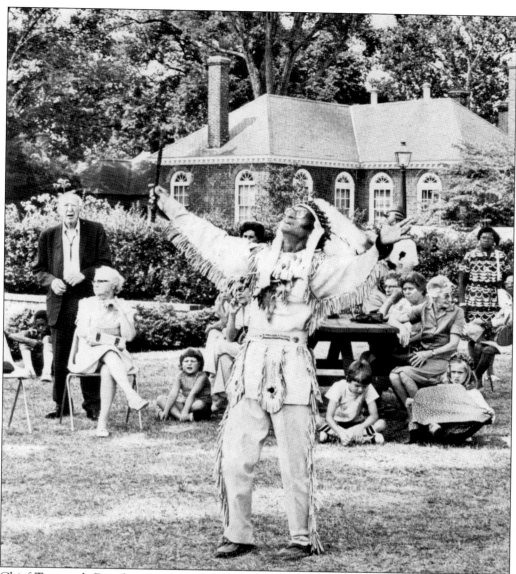

Chief Tecumseh Deerfoot Cook of the Pamunkey tribe participated in events in the historic Gloucester Courthouse Circle in 1976, commemorating the 325th anniversary of Gloucester and the 200th anniversary of the nation's founding. The Pamunkeys were probably the strongest of the tribes ruled by Powhatan when the English arrived in 1607. Powhatan's half-brother, Opechancanough, ruled them. After he led a 1644 uprising where 400–500 settlers were killed, the English retaliated by destroying Pamunkey villages. Later Opechancanough was captured, jailed, and shot. Laws and procedures to establish boundaries and relations between the two peoples continued to be recognized and repealed through the mid-17th century. In the end, however, the Virginia Indians were a decreasing threat to the European settlers, enabling the establishment of Gloucester County in 1651. Today eight tribes of the Powhatan Empire are recognized. The Pamunkey and Mattaponi reservations west of Gloucester, in King William County, include 1,000 acres as designated by mid-17th-century treaties. These reservations are the oldest in the United States. (Courtesy Tidewater Newspapers, Inc.)

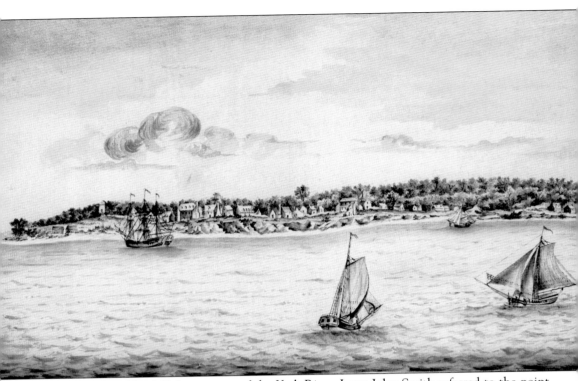

In 1608, Robert Tyndall drew a map of the York River. Later John Smith referred to the point of land that protruded from the northern bank as "Tindal's poynt." A tobacco warehouse was located there in 1633, and a fort was built at the site in 1667. Ten years later, when Virginia's executive council proposed replacing the Jamestown statehouse that was burned during Bacon's Rebellion, they suggested the thriving port at Gloucester, pictured in this image, *View of the Town of Gloucester, York River, Virginia, from the Logbook #406, HMS Norwich and HMS Success.* More influential voices called for the seat to be located at Williamsburg. After the destruction of the American Revolution and with the Virginia capital relocated to Richmond, Gloucester Town faded. According to Parke Rouse in *Along Virginia's Golden Shores,* "After the town was repeatedly damaged by hurricanes, residents moved out." (Courtesy The Mariners' Museum, Newport News, Virginia.)

Two

A HOUSE ON THE WATER

From the 17th century to the Revolution, Gloucester's population was scattered on farms and plantations with a preference for the waterfront. Most large landowners, however, were caught in the upheaval that followed the war. They had barely evolved into an antebellum routine before the Civil War wreaked havoc again. Through the remainder of the 19th century, Gloucester drew into itself as whites and former slaves alike struggled.

Soon, however, new settlers found Gloucester. One such gave Gloucester its "Land of the Life Worth Living" motto. The phrase grew out of a suggestion made by novelist Thomas Dixon Jr. in *The Life Worth Living: A Personal Experience*, written in 1905. Historian Parke Rouse said that "Gloucester County never had a better press agent" than Dixon, who bought Elmington on an impulse. While Dixon only lived there from 1899 to 1905, *The Life Worth Living*, said Rouse, "attracted many others to live along the shore of the Chesapeake Bay and its tributaries in those leisurely steamboat days."

At Elmington, Dixon nestled among the traditions of the county's first families: Booths and Taliaferros, Todds and Tabbs. From the riverside cottage where he wrote, he penned his thought, "Whether life is really worth living depends largely on where you try to live it." Speculators who agreed that Gloucester was a place where life could be lived blissfully dubbed the county "the land of the life worth living."

The number and variety of old houses along Gloucester's edge is incomparable. Built up during a period when tobacco, slave labor, and industrialists' family connections fueled fortunes, the houses were isolated on fingers of land situated for convenient access by water. Once motor vehicles moved transportation inland, they were considered inconvenient . . . and this is the reason they survive.

Many Gloucestonians, been-heres and come-heres alike, who share space nearby the old houses, are connected to the traditions that swirl around them and their early owners. Although most of the real estate is privately owned today, the hearts and minds of all who have ever claimed a Gloucester lineage possess it nonetheless.

Thomas Dixon Jr. used a log cabin near Elmington as his office. His books *The Leopard's Spots* (1902), *The Klansman* (1905), and *The Traitor* (1907) inspired D. W. Griffith's *The Birth of a Nation*, a film that fueled a revival of the Ku Klux Klan. Fame pulled Dixon back to New York. His career declined after World War I, and by 1919, he was destitute. (Courtesy William L. and Martha Ellen Brockner.)

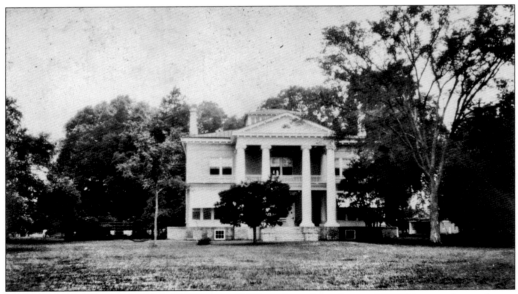

Dixon wrote, "[Elmington] has [500] acres, [350] under cultivation and [150] in woods . . . eleven horses, six cows, a dozen sheep, four bird-dogs, chickens, ducks, and turkeys . . . a two-acre garden with greenhouse for winter vegetables, an acre of strawberries, an acre of raspberries and dewberries and two acres in grapes; an old orchard and a young one with all the fruits of the temperate climate." (Courtesy William L. and Martha Ellen Brockner.)

He continued, "The Old Dominion steamer . . . gives us daily mail and traffic with . . . the outside world. There are no railroads. . . . [On] North River we see from our porch fourteen water-front homes. . . . [The area is] intersected by a network of tide rivers and creeks . . . making it a veritable rural Venice." (Courtesy William L. and Martha Ellen Brockner.)

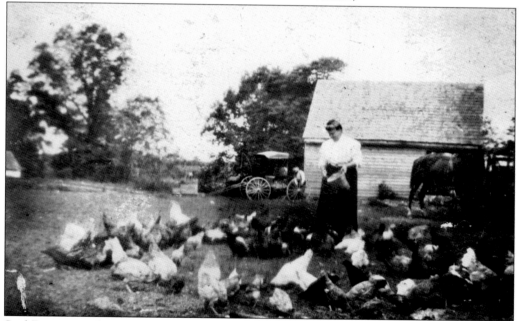

Said Dixon, "cool streams . . . turn our millwheels and pour their new life into the sea, giving us the finest oysters in the world. . . . The fields are full of quail. They nest in the garden and . . . mix with the chickens; while in unbroken reaches of . . . forests roam flocks of wild turkeys." (Courtesy William L. and Martha Ellen Brockner.)

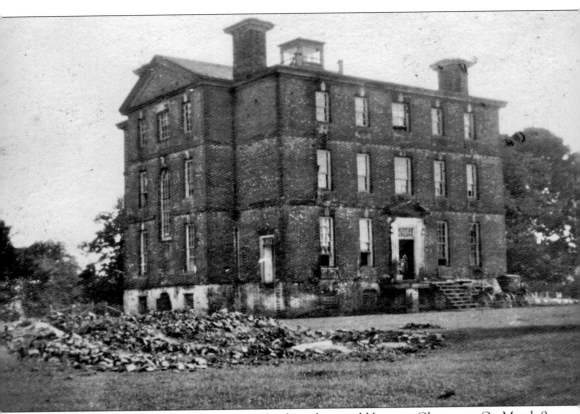

George Menefie received early patents on land in what would become Gloucester. On March 9, 1639, he was granted 3,000 acres that extended one mile inland and ran along nearly five miles of York River waterfront. Descendants sold George Menefie's patent to John Mann, whose daughter, Mary Mann, married Matthew Page. Their son, Mann Page I, inherited the property. In 1725, he began building Rosewell, the York River plantation house that was reputed to be the best in Virginia, with his second wife, Judith Carter, daughter of Robert "King" Carter. When Mann Page II inherited Rosewell, he completed the house his father started while finding the means to pay off the considerable debts incurred in building the elaborate house. The Page family struggled as the tobacco economy declined and the area recovered from the loss of wealth and destruction of property that followed the Revolutionary War. They sold Rosewell in the 1840s, and the mansion languished during the Reconstruction era. (Courtesy William L. and Martha Ellen Brockner.)

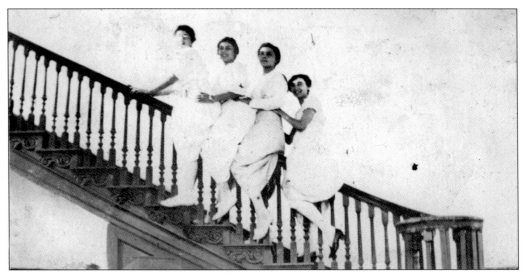

From left to right, Nellie Deans Taylor Greaves, Rosa Deans Barr Yeatman, and two unidentified friends pretend to slide down the banister at Rosewell. The Taylor family owned Rosewell when it burned in 1916. The mansion was never rebuilt, but the Rosewell Foundation preserves and exhibits what remains today. (Courtesy William L. and Martha Ellen Brockner.)

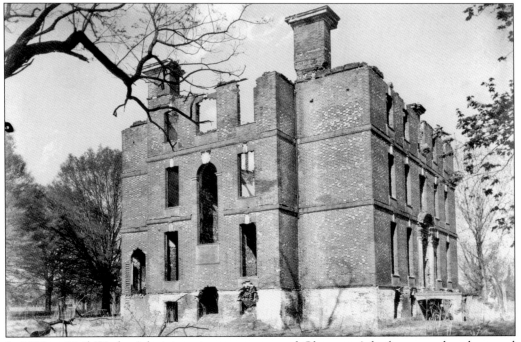

In 1933, a Civil Works Administration team surveyed Gloucester's built past and took several photographs of Rosewell. The Depression-era program gave employment to architects and historians who did much more than document bricks and wood: in many cases, their photographic art captured the fulsome spirit of Gloucester's and Virginia's pre-Revolutionary golden years. (Courtesy Library of Congress, Prints and Photographs Division, Historic American Buildings Survey, HABS VA,37-WHIMA,V2-4.)

In 1793, John Page sold a portion of the original Menefie grant to John Catlett, who built the original portion of Timberneck. This photograph shows the Catlett dwelling with family members gathered in the front around 1900, when Charles Catlett, a Gloucester County judge, owned the enlarged house. (Courtesy Special Collections, Earl Gregg Swem Library, College of William and Mary.)

Today Catlett Island's marshland in front of the house and between Timberneck and Cedarbush Creeks is part of the Chesapeake Bay National Estuarine Research Reserve, managed by the Virginia Institute of Marine Science. Since the 1940s, the Gloucester Point facility has helped citizens and future owners of waterfront property understand and appreciate the role of healthy wetland habitats in cleaning water and providing nursery grounds for seafood. (Author's photograph.)

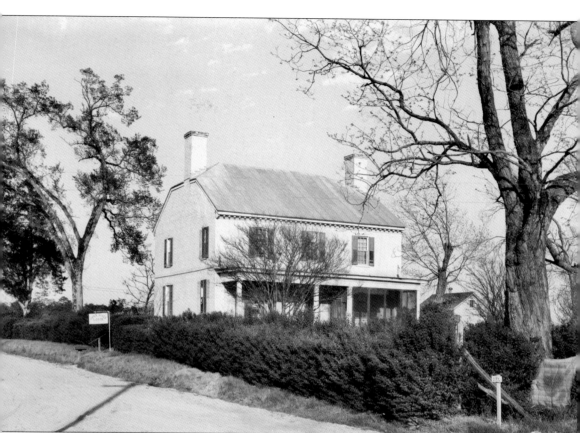

John Stubbs was granted a patent to a York River area called the Cappahosic tract in the 17th century. This house with clipped gables and eight corner fireplaces was built on a bluff overlooking the river around 1700. In the mid-18th century, William Thornton operated a ferry and lodging house at Cappahosic Landing. In his biography of Robert E. Lee, Douglas Southall Freeman wrote that when Lee and his son Robert visited White Marsh, the home of "Dr. Prosser Tabb" and Mrs. Tabb, his "Cousin Rebecca," they "drove to West Point, put their conveyance aboard the Baltimore steamer, and went very comfortably to Cappahosic Wharf," where they would have seen this handsome structure. When surveyors from the Civil Works Administration took this photograph in the 1930s, they listed it as Baytop. A sign along the road advertises the house as York River Lodge. Today it is called Cappahosic House. (Courtesy Library of Congress, Prints and Photographs Division, Historic American Buildings Survey, HABS VA,37-CAP,V1-1.)

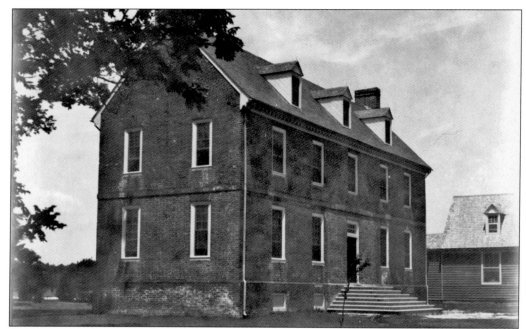

A 1651 land grant conveyed property to John Perrin. In the mid-18th century, his grandson, Capt. John Perrin, built Little England on the site. Because of its commanding view, French soldiers used the brick house during the buildup to the Battle of Yorktown in 1781. During the War of 1812, the house was used as a hospital. (Courtesy Library of Congress, Prints and Photographs Division, Historic American Buildings Survey, HABS VA,37-GLOPO,1-1.)

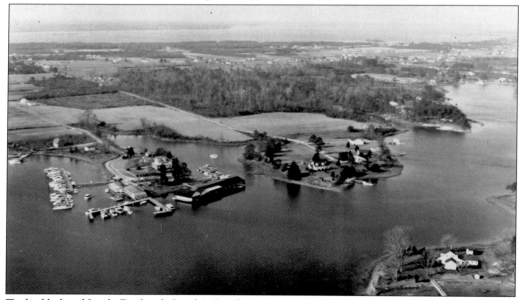

Tucked behind Little England, Sarah's Creek was reputed to be a safe harbor for warships. In this 1958 view, the King-Robins Marina (which became the York River Yacht Haven) can be seen to the left, or west, side of Sarah's Creek. Little England is located to the right, or east, but is not within this picture's frame. (Courtesy Walter G. Becknell.)

A 1960 aerial view illustrates property along the York River and provides a view across to the Severn River and Mobjack Bay. Rosewell, Timberneck, and Cappahosic House are beyond the photograph's boundary to the left of the York River Bridge. Sarah's Creek is in the center and Little England faces the York River on land to the right. Land's End is located on Robins Neck, in the distant center. (Courtesy Walter G. Becknell.)

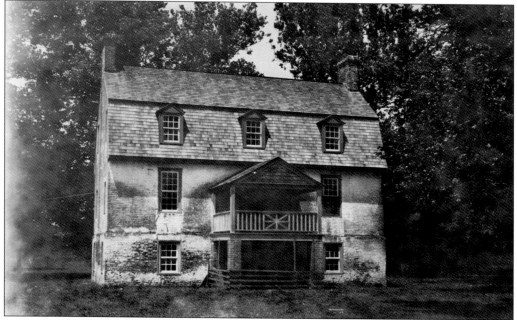

Land's End sits high on the flat marshland at the tip of Robins Neck, where it overlooks the Severn River's juncture with the Mobjack Bay. The builder, sea captain John Sinclair, dispatched messages from Yorktown to Rhode Island asking the French fleet to blockade the Chesapeake. His speedy voyage hastened the British surrender that ended the American Revolution. (Courtesy Library of Congress, Prints and Photographs Division, Historic American Buildings Survey, HABS VA,37-NAX.V,1-2.)

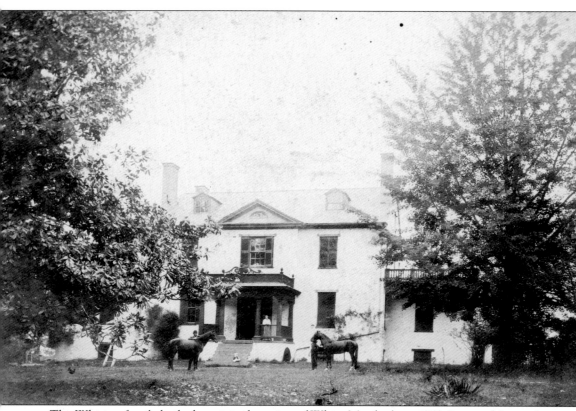

The Whiting family built the original portion of White Marsh about 1750. It passed from a later owner, Thomas Reade Rootes, to his second wife and her Prosser children from an earlier marriage. A Prosser daughter married John Tabb, son of Philip Tabb of Toddsbury. The combined Tabb and Prosser fortune was considerable, and the family owned much land and many slaves. In 1847, Adam Foster wrote, "I had heard a great deal about the wealth of Mr. Tabb. . . . The one half, however, had not been told. Before reaching the family mansion, you ride miles and miles through a park such as but few English noblemen can boast of. The house stands upon an eminence overlooking nearly all cultivated land belonging to the estate, which extends for miles, to the Severn River on the right, and the Ware River on the left. The dinner table groaned under the load of good things, but the spacious room could not contain all the relatives." (Courtesy Special Collections, Earl Gregg Swem Library, College of William and Mary.)

Based on the appearance of the house in the background and this photograph's history of ownership and its location in a family album, a Tabb family reunion was held at White Marsh after many young Tabb cousins returned from service in World War I. A John Tabb grandson and Civil War veteran may be the bearded gentleman in the center. (Courtesy William L. and Martha Ellen Brockner.)

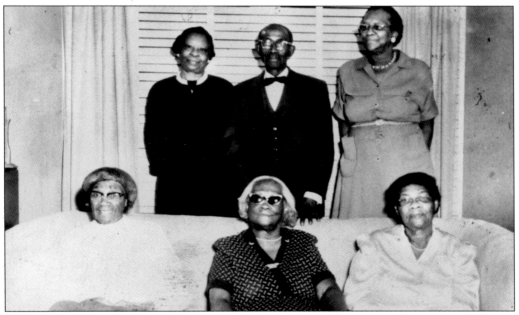

African American Tabb family descendants bear names that attest to their ties with former slave-owning families. Pictured at a family gathering about 1940 are, from left to right, (seated) Henrietta Tabb Redcross, Virgie Tabb Stokes, and Fannie Tabb Stokes; (standing) Mrs. Prosser (Martha Cotton) Tabb, Prosser Tabb, and Hannah Tabb Stokes. The family is descended from John Tabb Sr., born in 1797. (Courtesy Cleo Gregory Warren.)

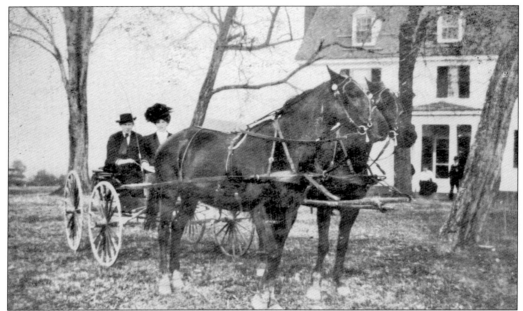

Due to its placement in a photograph album and architectural features of the structure, this *c.* 1900 photograph of a couple in a handsome buggy may have been taken in front of the house that became a Gloucester Training School dormitory. The house was destroyed in the 1950s, before the present-day T. C. Walker Elementary School was built on the site. (Courtesy William L. and Martha Ellen Brockner.)

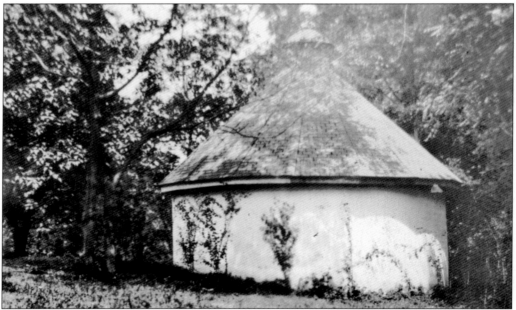

Round icehouses were familiar outbuildings during Gloucester's pre-electric age. The cool structure with a deep interior was packed with ice broken from the surface of nearby ponds and used to store foods that required low temperatures, such as milk, to extend their usefulness. (Courtesy William L. and Martha Ellen Brockner.)

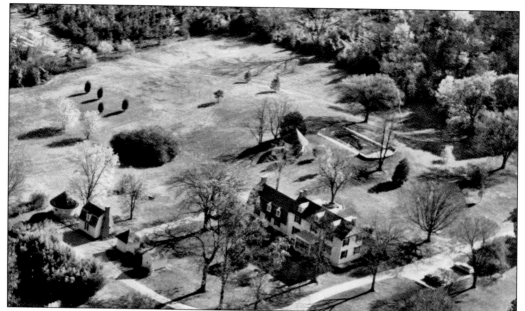

Rev. John Dixon, Kingston Parish rector and College of William and Mary divinity professor, built the oldest parts of Airville in the mid-18th century. The house is sited on a bluff overlooking the Ware River. Confederate general William B. Taliaferro said that his father, Warner Throckmorton Taliaferro, remembered watching British War of 1812 maneuvers from the portico at Airville. (Courtesy Walter G. Becknell.)

Jousting tournaments were popular in Gloucester as they were across the South, born out of an interest in books by Sir Walter Scott such as *Ivanhoe*. The tradition, pageantry, and gaiety that surrounded jousting provided an occasion to tout chivalry, horsemanship, and the romantic notion of white Southern womanhood. Such tournaments took place in Robins Neck and at Roaring Springs. (Courtesy William L. and Martha Ellen Brockner.)

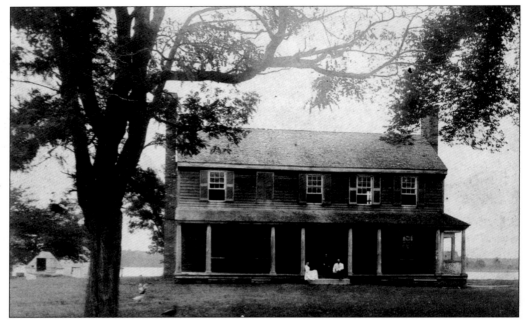

Goshen was built in the mid-18th century. In 1865, Maj. William Kennon Perrin lived at Goshen, and the individuals pictured in front of the house may be Perrin family descendants. (Courtesy Special Collections, Earl Gregg Swem Library, College of William and Mary.)

According to Emmie Ferguson Farrar in *Old Virginia Houses*, Henry Clay came ashore at Level Green during a political campaign. She acknowledges that tales are tales when she recalls Gen. William B. Taliaferro as having said that Gloucester's "old seats have all of them their histories and traditions full of suggestions to romantic and imaginative minds." (Courtesy Tidewater Newspapers, Inc.)

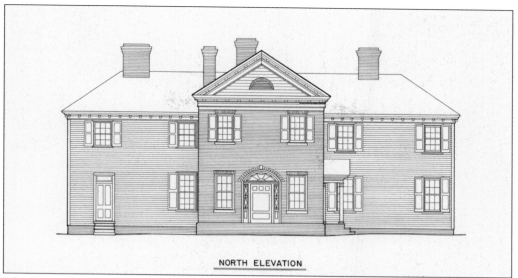

NORTH ELEVATION

John Boswell and John Booth conducted a tobacco exporting business on the North River site where Belleville mansion was built. The earliest portions date to 1658. Thomas Booth acquired the entire property by indenture in 1705. Later Francis Amanda Todd Booth and her husband, Warner Throckmorton Taliaferro, inherited Belleville. Their son, William Booth Taliaferro, was born there in 1822. (Courtesy Library of Congress, Prints and Photographs Division, Historic American Buildings Survey, HABS VA,37-WARNE.V,1-2.)

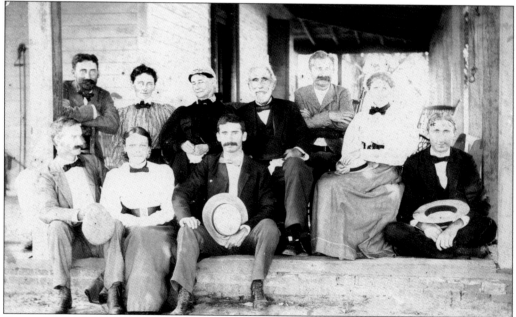

General Taliaferro's father, Warner Throckmorton Taliaferro, built a home on adjoining land for his son and named it Dunham Massie after a Booth ancestral home. The house was completed while the son was serving in the Mexican War. General Taliaferro died there in 1898. In this photograph, he is seated in the center. His wife and children surround him. (Courtesy Special Collections, Earl Gregg Swem Library, College of William and Mary.)

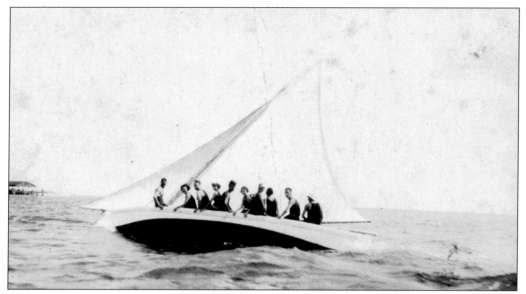

The North River was said to be the most affluent and sociable of Gloucester's four rivers. Homes with sweeping lawns and river views were enjoyed by generations of clans of close-knit first families, Northern industrialist cousins, and fortunate "come-heres." (Courtesy William L. and Martha Ellen Brockner.)

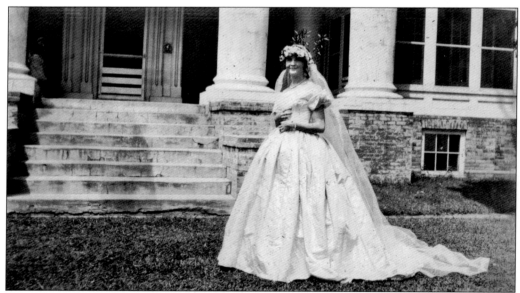

A bride poses in front of Elmington, located on land granted to Edmund Dawber in 1642. John Tabb of White Marsh built the present house for his son, John Prosser Tabb, in 1848. Before remodeling it, Thomas Dixon described Elmington as "a square brick structure finished with Portland cement and painted brown." (Courtesy William L. and Martha Ellen Brockner.)

One of the most well-known North River homes is Toddsbury, built by Christopher Todd on land patented to Thomas Todd, his grandfather, in 1665. The younger Todd died without a male heir, and his daughter, Lucy, married Edward Tabb. Todd and Tabb descendants occupied the house until the mid-19th century. (Courtesy Tidewater Newspapers, Inc.)

Toddsbury is located on a point along the south bank of the North River near its navigable end. This early-20th-century view reveals a working farm with horses, sheep, chickens, and geese roaming the yard. An enclosed room topped a riverfront porch, providing the best seat in the house to watch for packet boats and visitors. (Courtesy Library of Congress, Prints and Photographs Division, Historic American Buildings Survey, HABS VA,37-NUT.V,1-4)

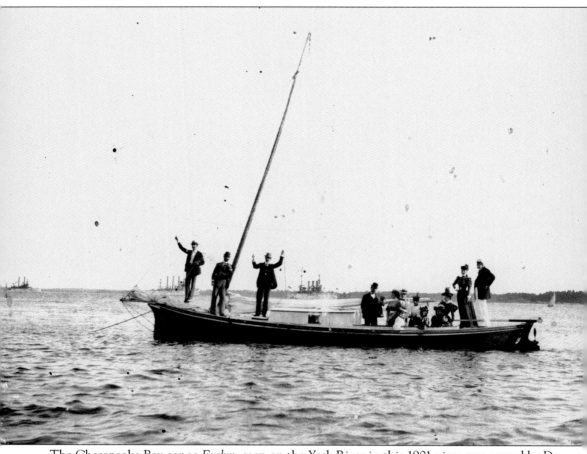

The Chesapeake Bay canoe *Evelyn*, seen on the York River in this 1901 view, was owned by Dr. Philip A. Taliaferro. On board from left to right are Capt. Lee Robins, Judge James L. Taliaferro, William C. L. Taliaferro, Franklin P. Dabney, four unidentified ladies, Miss Evelyn Dabney (seated), two unidentified ladies, Nina Taliaferro (standing), and Dr. Taliaferro. An inscription on the back of the photograph says that ships of the Atlantic Fleet were training in the York River and can be seen in the photograph behind the Taliaferro group. (Courtesy Special Collections, Earl Gregg Swem Library, College of William and Mary.)

Three

GLOUCESTER'S
STRATEGIC POINT

Gloucester's geography gave birth to its plantation culture. Another feature, a jut of land on the north bank of the York River, resulted in its designation as a strategic outpost.

A fort was located at Tyndall's Point in 1667 for protection of the colony's interior when England was at war with Holland. In 1680, the Virginia Assembly recognized the value of the location by naming it a tobacco inspection port. In 1686, a traveler observed a brick fort with 20 to 25 cannons at Gloucester Point.

The British army refortified the point in August 1781 during the final acts of the American Revolution. While British general Charles Lord Cornwallis dug in at Yorktown, British and Hessian soldiers secured Gloucester Point under Lt. Col. Banastre Tarleton. Soldiers needed access to Gloucester to forage farms for food and as an escape route, if needed. The colonists' French allies infiltrated the Gloucester countryside to hold the British in their Gloucester Point camp.

On October 19, 1781, terms of surrender were drawn up. Later the British surrendered to the American and French forces in ceremonies at Yorktown and Gloucester Point.

After the war, Gloucester Point continued to be fortified to a lesser extent in case the British assaulted their former colony. However, a decline in Gloucester's strategic and political importance accelerated through the post-Revolution years.

In June 1861, the Army of the Confederate States of America fortified Gloucester Point by constructing a star-shaped fort and water battery using African American laborers, both free and enslaved. While the battery was under construction, Gloucester Point took fire from Union steamers. During the Peninsula Campaign, Gen. J. B. Magruder relied upon the cannon at the Point to defend the north end of fortifications lined across the James-York peninsula. In May 1862, however, the Gloucester Point Battery was abandoned and came under Union control. Federal forces retained this position through the remainder of the war.

Though many Gloucester troops withdrew to fight in the western and northern parts of the state, others stayed behind to protect property and hold Union troops to their Gloucester Point base.

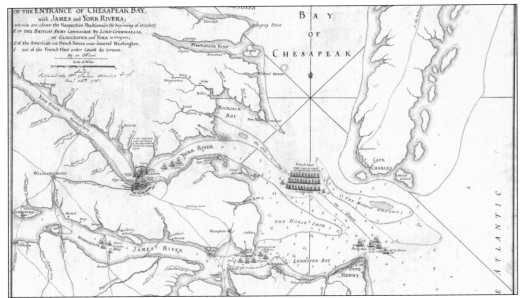

A map published in London one month after the surrender of British troops depicts ships, forts, and troop strength—1,500 Continentals, 2,000 French, and 800 Hessians. The Glebe or parish farm is noted, as are the names Fairfield, Lewis, Willis, "Throgmorton," and Clayton. In present-day Mathews County, Armistead, "Gwins I.," Milford Haven, and New Point Comfort are landmarks. (Courtesy Library of Congress, Geography and Maps Division, G3884.Y6S3 1781 .P5 Faden 90.)

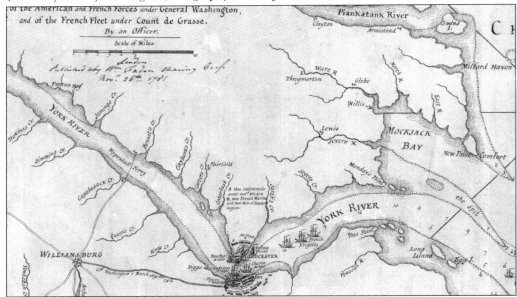

A detail shows the road from Williamsburg to "Capahosack" Creek and "Rippenhall" Ferry, which crossed to Cappahosic. It names "Portan Bay" and Jaming's, Bennet's, "Claybunks," Carters, and Cedarbush Creeks to the west of Gloucester Point and Sarah's and Segers Creeks and Monday's Point to the east. "Mockjack" Bay rivers include the Severn, Ware, North (present-day Gloucester), and East (present-day Mathews). (Courtesy Library of Congress, Geography and Maps Division, G3884.Y6S3 1781 .P5 Faden 90.)

A map published in Philadelphia by Sebastian Bauman, a major in the New York or 2nd Regiment Artillery, and dedicated to "His Excellency Genl. Washington" depicts troop lines, ships, and siege operations at York and Gloucester. (Courtesy Library of Congress, Geography and Maps Division, G3884.Y6S3 1782 .B3 Vault : Roch 63.)

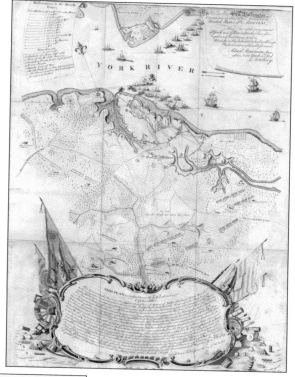

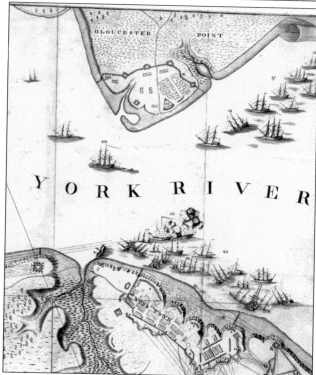

A detail from Bauman's map focuses on the battle scene. The lines of fortification drawn behind Gloucester Point enclose a plan of the streets of Gloucester Town. Sarah's Creek is also depicted, indicating its role as an anchorage. (Courtesy Library of Congress, Geography and Maps Division, G3884.Y6S3 1782 .B3 Vault : Roch 63.)

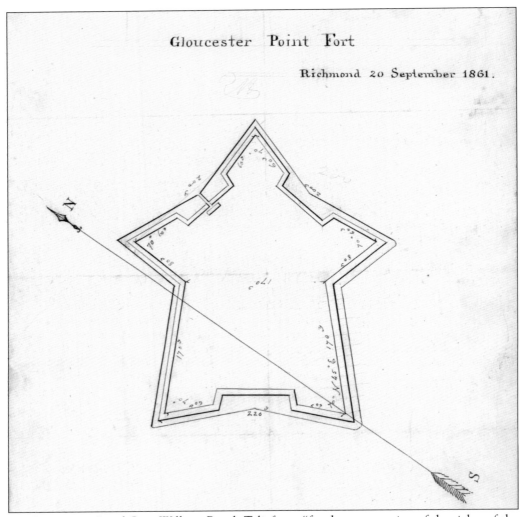

Gloucester Point Fort

Richmond 20 September 1861.

"In the war . . . ," said Gen. William Booth Taliaferro, "for the preservation of the rights of the States on the one side, and for the unification of the country on the other, the first hostile shot . . . in Virginia fell . . . at . . . Gloucester Point," which stood between the Union at Fort Monroe and the Confederates in Richmond. After the Confederate defeat, Taliaferro fought with Stonewall Jackson in the Shenandoah Valley and Northern Virginia. His stepbrother, Dr. Phillip A. Taliaferro, fought with him but returned to Gloucester, where his home, Burgh Westra, was used as a hospital. Four hundred enslaved and free African Americans conscripted from Gloucester and surrounding counties built the fortifications. In 1863, free black James Daniel Gardner of Ware Neck crossed from Gloucester Point to Yorktown to join the Union's Colored Troops. He received the Medal of Honor for rushing in advance of his brigade to shoot a rebel officer at the Battle of New Market Heights. (Courtesy Library of Congress, Geography and Maps Division, G3884.G53S5 1861 .G5 Vault : Hotch 87.)

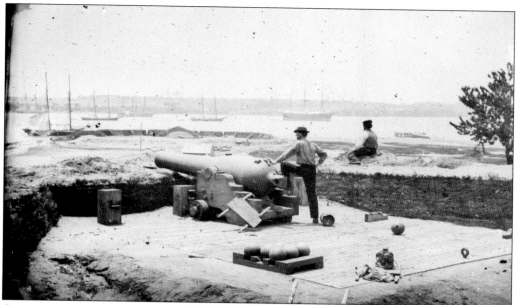

Gen. Robert E. Lee dispatched the 2nd Company of Richmond Howitzers to repel Union steamers at Gloucester Point. In May 1862, the outpost was captured by Union forces and remained a federal outpost throughout the war. In a photograph created in June 1862 by George N. Barnard, an 11-inch smooth-bore Dahlgren naval gun sits atop the stage-like earthworks. (Courtesy Library of Congress, Prints and Photographs Division, Civil War Photographs, LC-DIG-cwpb-00177.)

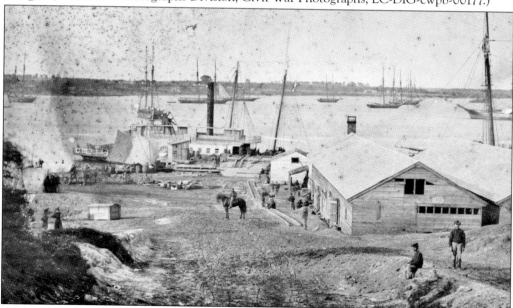

This George N. Barnard photograph shows the Union stronghold from the Yorktown side, across the warship-filled river from Gloucester. While there was little direct military conflict after 1862, the occupation by enemy forces threatened those who lived in the area for miles around. Soldiers raided the countryside for food and supplies for the duration of the Civil War. (Courtesy Library of Congress, Prints and Photographs Division, Civil War Photographs, LC-DIG-cwpb-01630.)

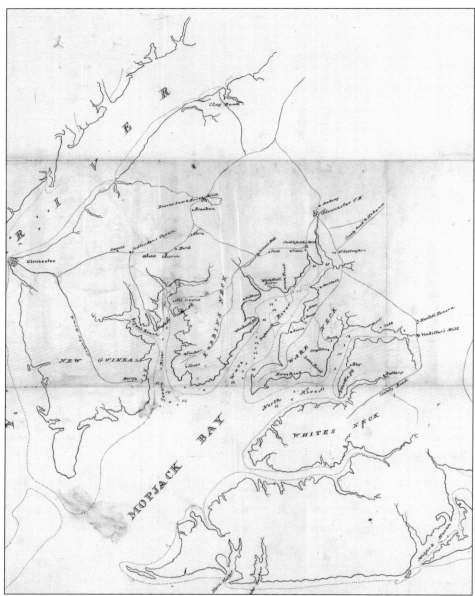

Maps guided Union troops by land and sea to pillage Mobjack Bay area plantations and mills for grain, livestock, and supplies. Gristmills and barns were burned to render them useless to Confederates. Pews from Abingdon Church became firewood and the building a stable. After the war, property was neglected. In *The Honey-Pod Tree*, Thomas C. Walker said, "The plantations were broken up . . . and their owners and families, now poverty-stricken and shocked by loss of the war, had largely disappeared. . . . Former slaves were living in crowded one-room cabins and eking out a meager subsistence from crabbing, digging oysters, and fishing. They did almost no gardening, habituated as they were to the direction of white overseers before the arrival of the freedom that threw them into confusion and even greater poverty. . . . The white people . . . had lost their wealth but my people had not acquired it; everybody was poor and drifting." (Courtesy Library of Congress, Geography and Maps Division, G3882.Y6S5 1862 .H8 Vault : CW 672.5.)

Four

MAKING A LIVING IN GLOUCESTER

Within 100 years of Gloucester's tobacco boom, the soil was sapped of nutrients. Landholders who lost fortunes during the wars gradually sold off their land to smaller farmers, and many people moved away.

Still, harvesting the bounty of land and sea was the focus of day-to-day life in Gloucester. In 1920, the census listed 1,250 farms, averaging 48 acres, and a population of 11,894. Related industries such as milling and boat building flourished. Medical, law, and retail businesses, along with ferries, ordinaries, and travel-related businesses such as blacksmiths' shops were located in early Gloucester. Tide and watermills were also part of the commercial landscape.

Gloucester's agriculture diversified to include grains, potatoes, beans, and melons. Farmers found raising livestock to be a less labor-intensive livelihood. Timber was harvested; lumber and raw materials were shipped by steamboats to railroad terminals. As scientific skills were needed to coax more from the earth, demonstrators taught farmers how to use agricultural management methods. Agricultural fairs became a means to celebrate accomplishments. At the same time, women's clubs were developed to learn and boast homemaking skills.

The development of refrigeration and East Coast markets increased demand for seafood. From the 17th century, plentiful fish, oysters, and crabs had been harvested for local use. Beginning in the 19th century, quantities of oysters, crabs, sturgeon, sheepshead, and rockfish were transported to distant cities, and the seafood industry provided a satisfying way to manage an independent lifestyle. Each year, the Guinea Jubilee is held to celebrate the history of Gloucester County's watermen.

Faster means of transportation and refrigeration also supported a new industry—daffodil farming. Gloucester's soil was recognized as ideal for the flower from the time of John Clayton, 18th-century Gloucester clerk and renowned botanist. Mrs. Eleanor Linthicum Smith of Toddsbury and Holly Hill is thought to be the first person to grow and sell daffodils as a business in the 1890s, but it wasn't until the Dutch industry took a chance on Gloucester growers that daffodil farming became an occupation. The modern Daffodil Festival and Show and Gloucester Historic Garden Week tours have sprouted from these traditions.

Roaring Springs was built by James Baytop Taliaferro on land granted to Mordecai Cooke in the 17th century. Positioned in the center of the county, the farm figured in other events: the Gloucester militia drilled along the road to Roaring Springs before the Civil War, and early-20th-century jousting tournaments were held at the plantation. (Courtesy Library of Congress, Prints and Photographs Division, Historic American Buildings Survey, HABS VA,37-GLO.V,4-11.)

During the antebellum years, William Stephen Field purchased Roaring Springs. One of the slaves he granted freedom was Thomas Walker, father of lawyer and educator Thomas Calhoun Walker, who was born in 1861. In his biography, T. C. Walker says he was born at nearby Spring Hill plantation, and that his mother's owner was named Baytop. (Courtesy Library of Congress, Prints and Photographs Division, Historic American Buildings Survey, HABS VA,37-GLO.V,4-10.)

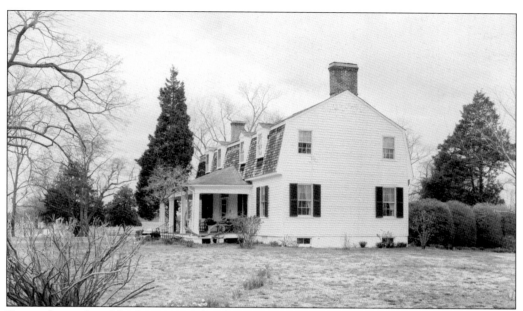

Descendants of wealthy financier-philanthropist Johns Hopkins owned two of the largest daffodil farms in the early part of the 20th century. Richard Mott Janney, who married Henrietta Snowden Hopkins, farmed Roaring Springs. Nicholas Snowden Hopkins, Henrietta's brother, married Selina L. Hepburn (first cousin of actress Katherine Hepburn) and built River's Edge on the North River. (Courtesy Library of Congress, Prints and Photographs Division, Historic American Buildings Survey, HABS VA,37-GLO.V,4-3.)

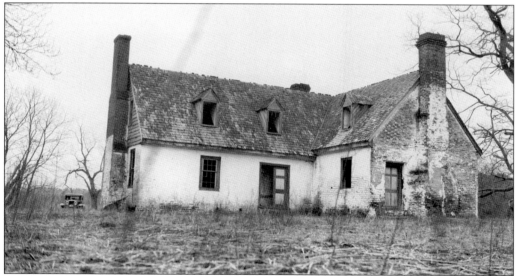

The Buckners built Marlfield in the early 18th century, once Gloucester's main road had improved to allow the inner portions of the county to be farmed. Joneses owned the plantation through the 20th century, and it was used for county meetings during the Civil War. The land around Marlfield was purchased in the early 20th century so that another crop—timber—could be harvested from its land. (Courtesy Library of Congress, Prints and Photographs Division, Historic American Buildings Survey, HABS VA,37-V,1-2.)

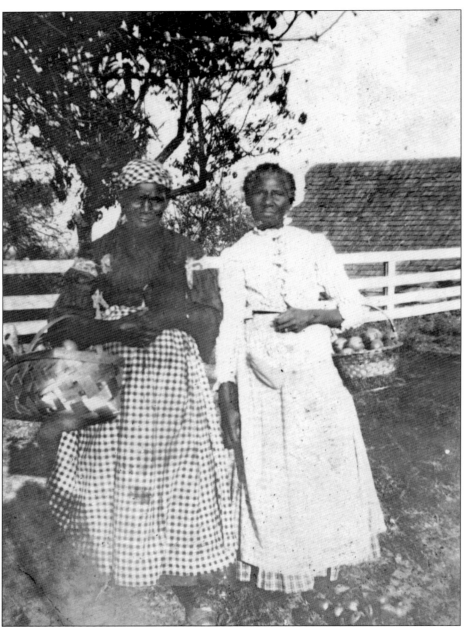

During the Civil War, some Gloucester planters, like Roaring Springs' Field, voluntarily freed their slaves. Other slave owners hid their slaves in an attempt to forestall the inevitable conclusion of the institution. Some slaves fled to Fort Monroe or joined the fight, where they lived behind Union lines. Some slaves accompanied Confederate owners and continued to serve them on the battlefront. After the war, although many former slaves left the area, others chose to stay on in their neighborhoods and work as employees of their former owners. Several photographs of African Americans, such as this one found in an "orphaned" family album, capture images of free blacks working for and living alongside the white families who had also chosen to stay in the rural community. (Courtesy William L. and Martha Ellen Brockner.)

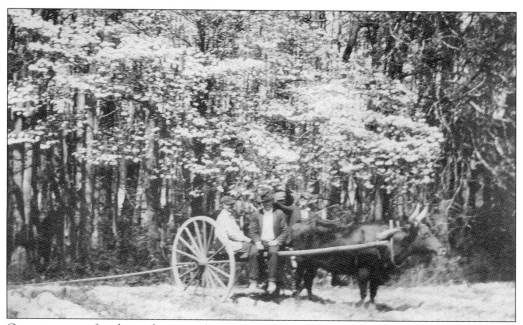

Ox carts were a familiar sight in rural Gloucester. This photograph reflects the slow pace of life as farms recovered. Official sources cited that farmers were disinclined to improve their acreage, but there was little extra money to put toward new methods and machinery. (Courtesy William L. and Martha Ellen Brocker.)

Farms had many attendant buildings that supported the tasks of nurturing and preserving farm products. This dairy house at Mount Prodigal represents such a structure, and the Historic American Buildings Survey photographer intended to record its architectural features. The melancholy scene is also a record of land, buildings, and spirits in need of improvement. (Courtesy Library of Congress, Prints and Photographs Division, Historic American Buildings Survey, HABS VA,37-GLO.V,3-7.)

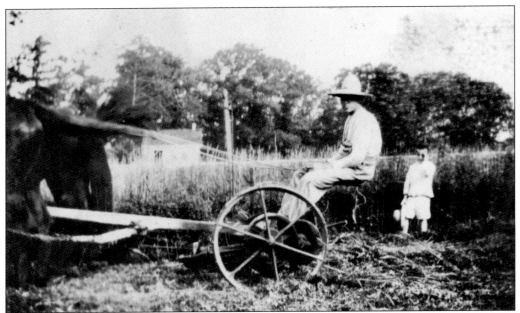

Turning wheels powered this sickle-bar mower. In remembering a local farmer of the period, T. C. Walker said, "I have always thought that this picturesque individual, dressed in overalls, brogan shoes, and a wide straw hat represented more than a general southern type." Crops of hay were grown as feed for horses, cattle, and oxen. (Courtesy Bill and Madelyn Weaver.)

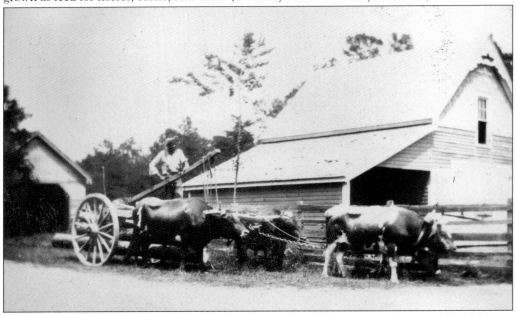

Around 1900, Frank Weaver used teams of oxen to drag felled trees to his sawmill. Although farmers had cleared much land for agriculture in the preceding 250 years, old timber was still available and land that had been farmed earlier had grown over. Timbering operations slowed when farmers were unable to invest in reseeding and modern forestry practices. (Courtesy Bill and Madelyn Weaver.)

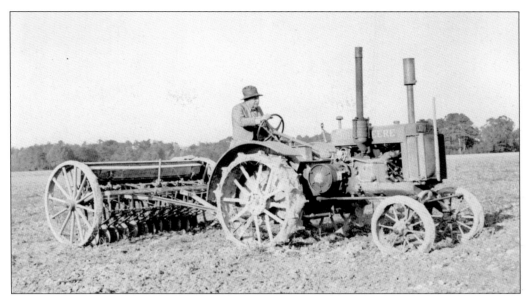

Frank L. Kerns noted "Dat's de Boss" on this photograph of Frank Weaver taken in 1933. The Weavers, a family of Mennonites, moved to Gloucester from Pennsylvania after the Civil War and built Burleigh farm. Around 1900, son Frank Weaver built his home, Woodberry. As the use of tractors increased, farmers were able to boost production while using fewer laborers. (Courtesy Bill and Madelyn Weaver.)

The juxtaposition of car and horse at Roane's farm reflects a transitional time when both types of transportation were useful. This photograph was taken as part of a Depression-era work project that also included a writer's project. Many life histories of Gloucester's citizens were compiled that enlighten our understanding of early-20th-century life and occupations. (Courtesy Library of Congress, Prints and Photographs Division, Historic American Buildings Survey, HABS VA,37-GLO.V,3-1.)

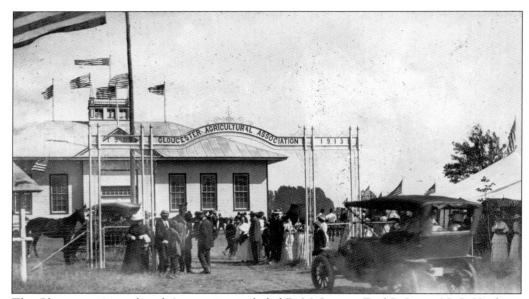

The Gloucester Agricultural Association included R. M. Janney, Fred B. Jones, N. S. Hopkins, W. S. Field, John L. Farinholt, J. M. Lewis, B. F. Weaver, William deWolfe Dimock, William J. Burlee, W. S. Mott, and L. C. Catlett, who founded the Gloucester Agricultural Fair in 1913 in the village of Gloucester Court House at Edge Hill. (Courtesy Bill and Madelyn Weaver.)

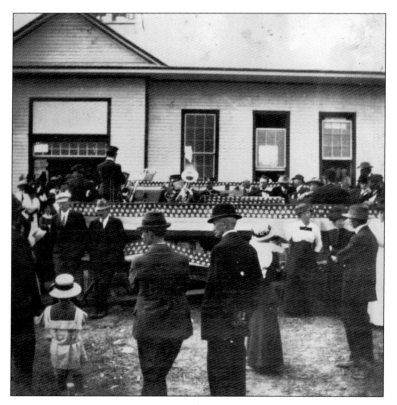

The Agricultural Fair boasted entertainment, amusements, and a school fair along with exhibits and competitions in farm products, livestock, poultry, and domestic arts and crafts. The collection of the Gloucester Museum of History includes a 70-page program for a fair held October 3–6, 1916. (Courtesy Bill and Madelyn Weaver.)

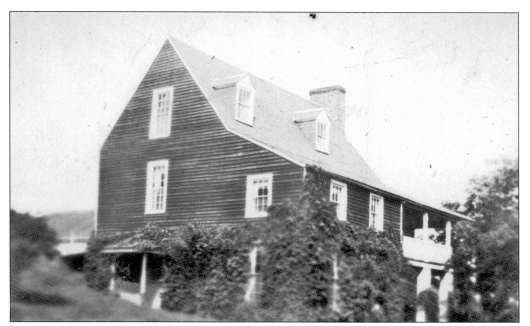

Legend held that a building on the fairgrounds, which became the Gloucester Woman's Club headquarters, was used as an ordinary. Historian Martha McCartney has noted that court records mention it as a mercantile establishment where Williamsburg merchants Roscow Cole and Jacob Sheldon conducted business in the early 19th century. Mid-20th-century merchant Thomas W. Field called the property Edge Hill. (Courtesy William L. and Martha Ellen Brockner.)

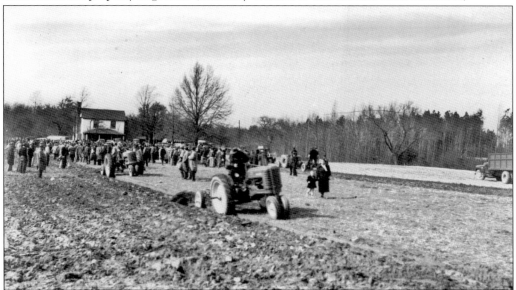

The Virginia Extension Service hosted field days in Gloucester so that farmers could share information and learn about new tools. As pictured here, the events attracted crowds of farmers and their families. In 1950, when Gloucester's population was 10,343 and farming was still a primary occupation, farmers were concerned about greater crop yields, soil conservation, and modern management practices. (Courtesy Virginia Tech Digital Library and Archives, AGR2967.)

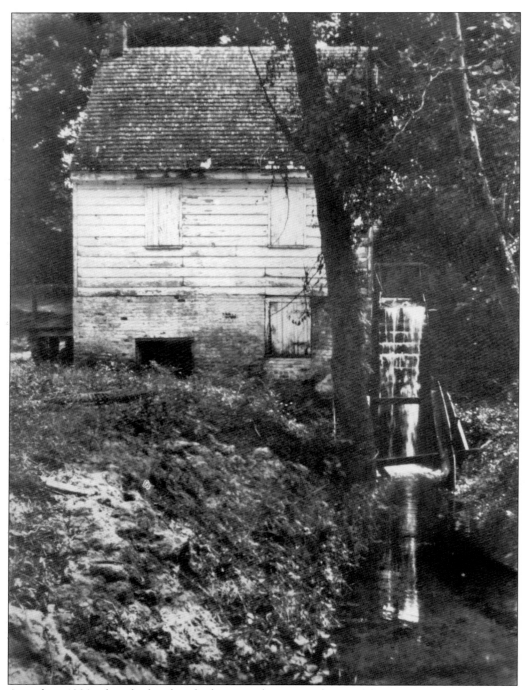

As early as 1800, wheat had replaced tobacco as the principal crop of the region, and mills—water, wind, and tide—were located around the county. This photograph is believed to be of Robin's Mill, which was located near Roane's Store and Post Office. Near Gloucester Point, where the land is flat, tidal currents powered the mill on Tidemill Road. (Courtesy William L. and Martha Ellen Brockner.)

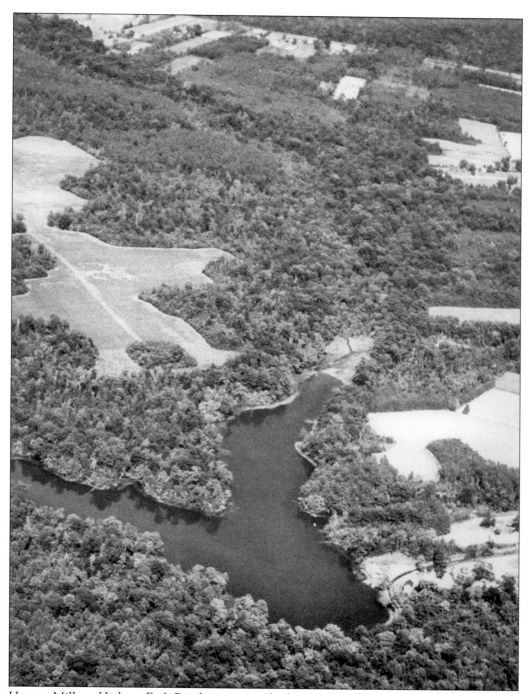

Haynes Mill on Hickory Fork Road is seen on the lower edge of the pond in this aerial view. Water coursed over the spillway to Carter's Creek and from there to the York River. The Corr farm, pictured above the pond, spread northwest. Corn and wheat were fed from a hopper to a stone surface, where another stone crushed the whole fruits into meal and flour. (Courtesy Walter G. Becknell.)

Late-19th- and early-20th-century sawmills were powered by steam engines. In *The Honey-Pod Tree*, Thomas C. Walker described enlarging Old Poplars School: "Some . . . traded . . . for lumber. . . . The sawmill proprietor was another Quaker by the name of Weaver. . . . He let some of our people work . . . and paid them in lumber." (Courtesy Bill and Madelyn Weaver.)

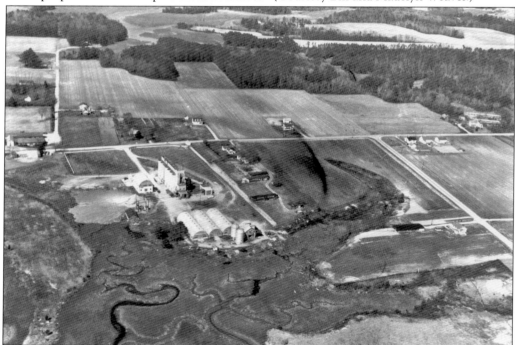

Louis Groh settled in Gloucester after being stationed at Camp Penniman, located across the York River in York County, during World War I. He sold seed from his granary to farmers throughout Gloucester while his wife ran the store and post office at Clay Bank landing. (Courtesy Walter G. Becknell.)

Willie Gregory Sr. sold watermelons from a truck. From the 1930s, he helped his father, Robert Gregory, on the family's 12-acre farm, located along Guinea Road. The family also raised hogs and grew other crops, including peanuts, sweet potatoes, white potatoes, watermelons, strawberries, peas, green beans, collards, kale, and tomatoes. Earlier Robert Gregory had slowly acquired the farm by buying an acre with each $7 he earned. (Courtesy Cleo Gregory Warren.)

Into the 20th century, farm families were mostly self-sufficient. Joe Frank Bonniville, born in Guinea in 1881, moved to Robins Neck, where he supported his family by clamming in Whittaker Creek in a small boat called a punt. He grew vegetables and fruit and raised chickens and hogs. During the August Storm of 1933, he saved his hogs by tying them in the punt and holding the boat's rope through a second-story window. (Courtesy Nan Belvin McComber.)

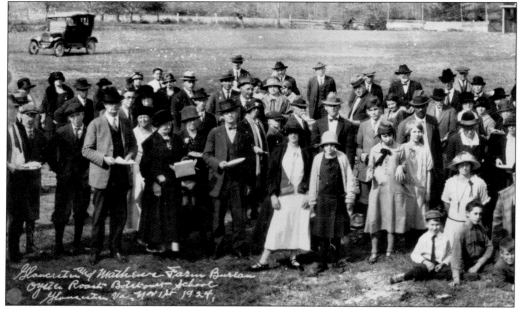

The Farm Bureau held an oyster roast at Botetourt High School in November 1924. The national organization was founded by groups of farmers who recognized the need to work together following the boll weevil crisis, when the insect destroyed cotton crops across the South. The local group gathered to promote profitable farming in the area. (Courtesy Bill and Madelyn Weaver.)

A display of farm products illustrates that farmers grew a variety of vegetables—squash, tomatoes, melons, potatoes, and more—to sell to East Coast cities. So-called truck farming, the practice of growing vegetable crops on a large scale for shipment to distant markets, declined as the use of large-capacity refrigerated trucks increased and truck farming was conducted on cheaper lands in the South and West. (Courtesy Bill and Madelyn Weaver.)

Captured in this 1949 photograph, Henry Hutchinson raised poultry on his farm near Gloucester Court House. Previously most Gloucester families tended flocks of chickens for eggs and meat and occasionally sold any surplus. Farmers like Hutchinson represented the trend toward poultry industry commercialization. The production of eggs came first. Raising chickens for meat was a later development. (Courtesy Virginia Tech Digital Library and Archives, AGR4125.)

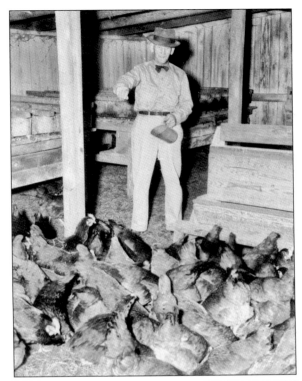

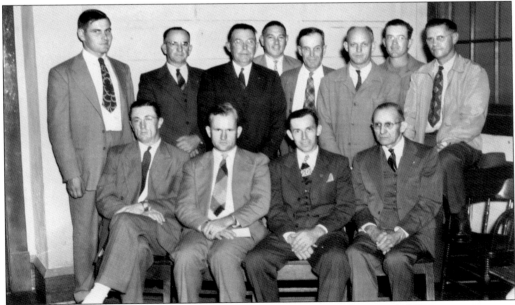

Members of the Gloucester Poultry Committee posed for this 1949 photograph. The group represents the influence of the Virginia land-grant college systems' extension services on rural communities. The poultry industry expanded rapidly during World War II, because of the shortage of beef and pork, to become one of the most efficient means of providing protein for human consumption. (Courtesy Virginia Tech Digital Library and Archives, AGR4378.)

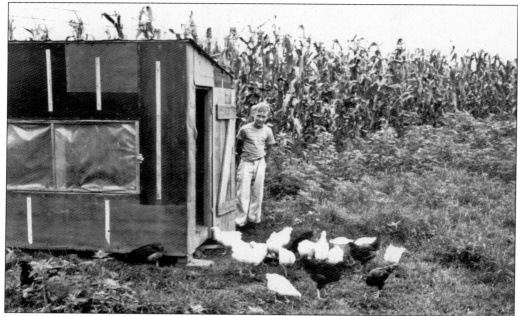

Dedicated to the concept of "learning by doing," 4-H clubs were established around the country in response to the need for better agricultural education. By 1950, a focus on contests and award programs encouraged many young people, such as Graham Blake of Bena, to enroll in 4-H projects to raise chickens and corn. (Courtesy Virginia Tech Digital Library and Archives, AGR0716.)

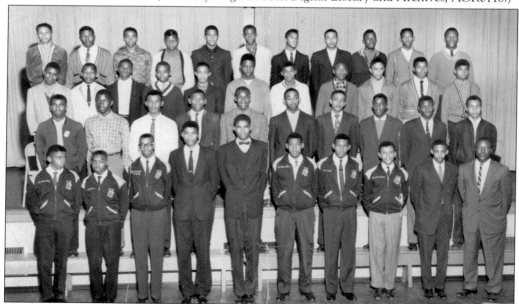

At T. C. Walker School, many young men were members of the Future Farmers of America, led by Stanley B. McMullen (first row, far right). The national organization was founded to promote public agricultural education and leadership. Future Farmers and Future Homemakers of America clubs were significant extracurricular programs in all mid-20th-century Gloucester schools. (Courtesy Cleo Gregory Warren.)

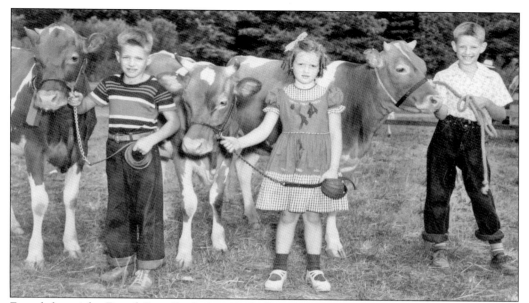

From left to right, David Gray, Ruth Ann Birdsall, and Jimmie Gray exhibit livestock at the 1951 Tidewater Fair. Children learned about the proper breeding, feeding, and care through Virginia Extension Service programs. Birdsall's father, Alton Gilbert Birdsall Sr., was Gloucester's extension agent. An interest in animal care led to the establishment of Gloucester Veterinary Hospital by Ruth Ann's brothers, Gilbert Jr. and David Birdsall. (Courtesy Virginia Tech Digital Library and Archives, AGR0002.)

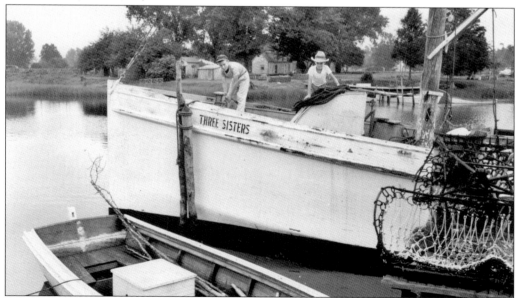

Graham and Freddie Blake tie up a deadrise workboat, *Three Sisters*. The heavy-duty boat had room to accommodate bulky tools and equipment and for tasks such as culling oysters and transporting crab pots. The larger workboat evolved from smaller log canoes because watermen who traveled further from shore to gather seafood needed the sturdier boat. (Courtesy Virginia Tech Digital Library and Archives, AGR0712.)

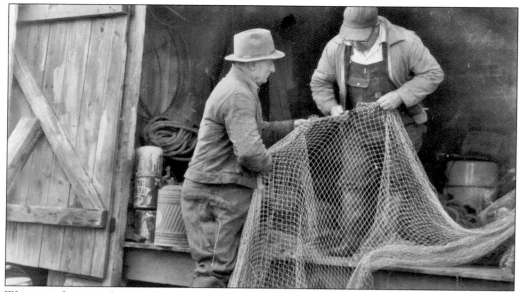

Watermen have used nets to harvest vast quantities of all types of fish, including herring, sturgeon, shad, rockfish, trout, sheepshead, spot, croaker, and flounder. Large-scale harvesting began in the 19th century, when the means developed for selling to distant markets. In the 1940s, some watermen were prosperous: Guineamen have recalled a legendary $40,000 haul of croakers in seine nets by watermen from Big Island. (Courtesy Walter G. Becknell.)

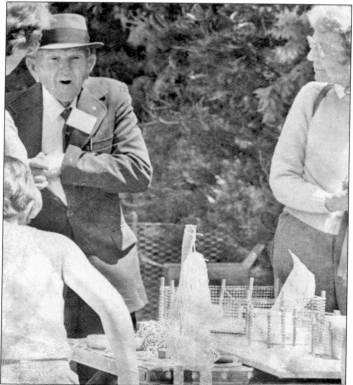

Retired waterman Henion Brown showed a replica of pound nets at a 1980s Dragon Run Festival and explained how they caught fish. The folklife festival was held for several years to encourage understanding of early work and lifestyles in the county. (Courtesy Tidewater Newspapers, Inc.)

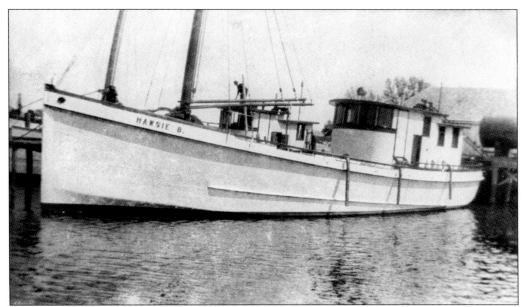

Capt. William Cary Brown, who lived at the end of Perrin Creek Road, where he operated a store and a railway, named his best boat after his daughter, Hawsie Brown. The large buy boat traveled up and down the Chesapeake Bay to buy the daily catch from working boats and take it to market. (Courtesy Walter G. Becknell and the family of Hawsie Brown Penn.)

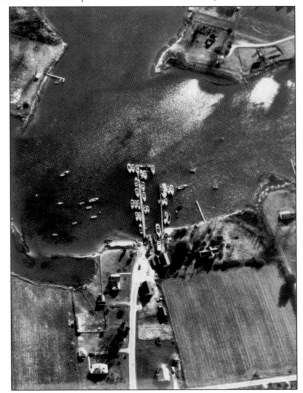

Fleets of hundreds of deadrise workboats were a common sight in the late 19th and early 20th centuries. Their crews of sturdy watermen left early in the morning and returned midday after working the waters for seasonally available fish and shellfish. A couple of dozen boats can be seen in this c. 1960 aerial view of a harbor just inside the mouth of Perrin Creek. (Courtesy Walter G. Becknell.)

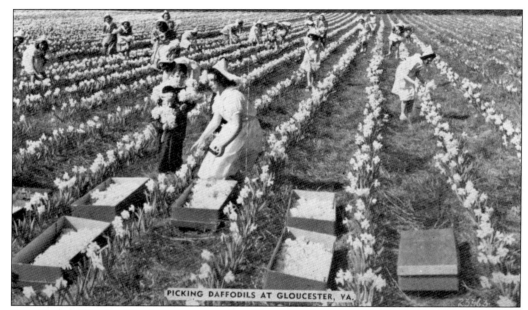

PICKING DAFFODILS AT GLOUCESTER, VA.

New Yorker Charles Heath was attracted to Gloucester by its tasty melons and fields of golden daffodils. Although the flowers had grown in Gloucester for centuries, Heath imported Dutch varieties and promoted the raising of quality bulbs. In 1926, when bulbs were quarantined from import to the United States due to a pest, Dutch sellers leased Heath's land and grew bulbs for market there. (Courtesy Brent and Becky Heath.)

A 1956 article in *The American Mercury* said, "Big interstate trucks rumble along every road and back lane . . . picking up cardboard boxes. . . . Within a few weeks about 24 million flowers go out of [Gloucester and Mathews Counties] for a return of up to a quarter-million dollars cash." The Daffodil Show has been held annually for more than 50 years. (Courtesy Brent and Becky Heath.)

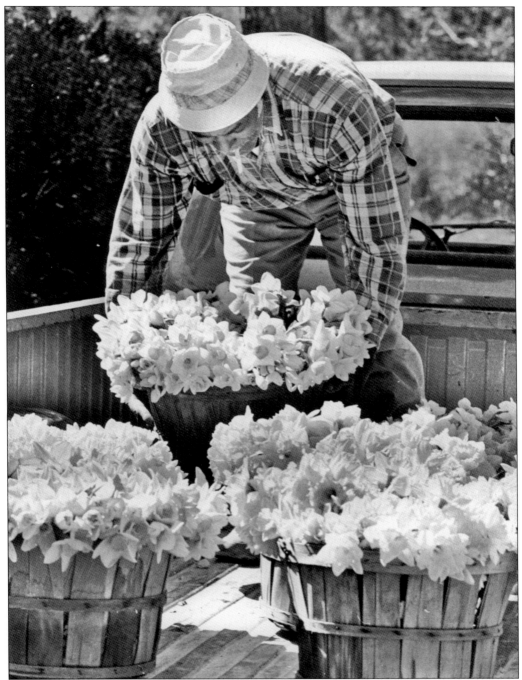

April is daffodil time in Gloucester. Before World War II, George Heath came home to manage his father's business. Although the industry declined, a few growers continued to harvest fresh flowers from Gloucester's fields. Katharine Heath, son Brent, and his wife, Becky, continued to grow thousands of varieties of bulbs at the Daffodil Mart in Ware Neck. (Courtesy Brent and Becky Heath.)

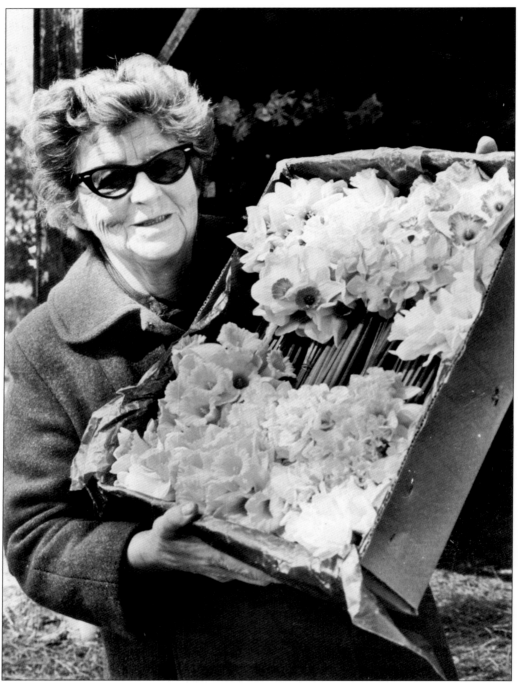

Katharine Heath, pictured with a shipping box of mixed daffodils, was a founding member of the American Daffodil Society. In the 1980s, Brent and Becky Heath encouraged Gloucester officials to sponsor daffodil festivities that resulted in Gloucester's Daffodil Festival, a celebration of daffodil farm tours, arts and craft shows, and a parade. A 1930s festival forerunner invited visitors along county routes to see blooming fields. (Courtesy Brent and Becky Heath.)

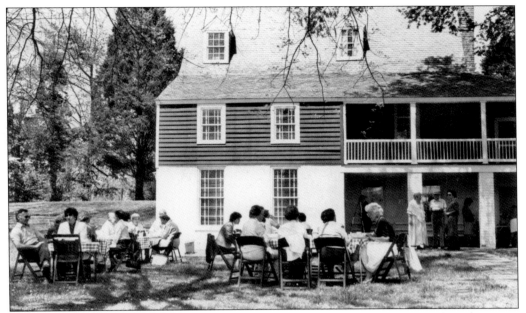

During Gloucester's 1986 celebration of Historic Garden Week in Virginia, the Gloucester Woman's Club hosted a luncheon on the lawn. Plantations and farms that once shipped products and flowers far afield now attract visitors to learn history and horticulture. (Courtesy Tidewater Newspapers, Inc.)

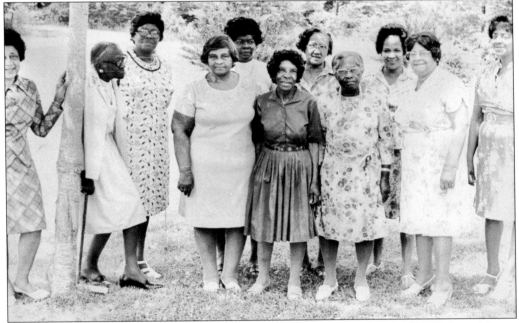

In the 1960s, the Ever-Blooming Garden Club included, from left to right, members Roberta Morris, Sue Brooks, Mary Johnson, Hester Washington Cook, Maude Lockley Blake, Nellie Henderson, Hallie Wilson Moore, Mabel Morris, Elaine Moore Washington, Willanna Holmes, and Helen Bolden, who met to discuss their vegetable and flower gardens. (Courtesy Dr. Dorothy Cooke.)

61

Several of Gloucester's old plantations and more recently constructed homes are decorated by Woman's Club members before they open for April's Garden Week tours. Mrs. Webster Rhoads arranges flowers for display in a home opened for Historic Garden Week in 1987. (Courtesy Tidewater Newspapers, Inc.)

Daffodil Show cochairman Jane Smith poses for the *Gloucester-Mathews Gazette-Journal* to encourage children to support horticultural traditions by entering blooms in the annual show. Young gardeners joining her are, from left to right, (first row) Antonia Joseph, Laura Ingles, and Sarah Matheson; (second row) Mac Ingles and Merrit Allaun. (Courtesy Tidewater Newspapers, Inc.)

The county fair celebrated the community and especially the farming way of life that had provided a livelihood for generations of Gloucestonians. Held at T. C. Walker School and then at the former Gloucester High School, which is present-day Page Middle School, the fair provided entertainment and competitions. (Courtesy Tidewater Newspapers, Inc.)

T. C. Walker had encouraged African Americans to own and cultivate land. An agricultural association provided agricultural demonstrators and encouraged fairs. Walker said, "On these occasions, products from many of the farms and schools are placed on exhibition for two days and the people—both white and colored—come from miles around to see and discuss them." (Courtesy Tidewater Newspapers, Inc.)

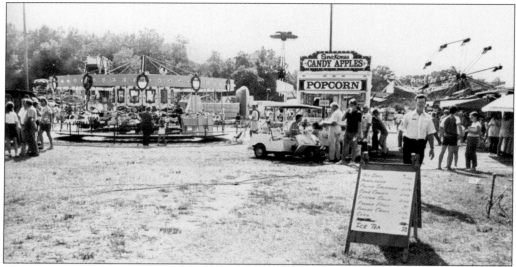

The Gloucester County Fair's midway included food, rides, and games. Although the tradition of county fairs was once strong and the Gloucester County Fair has continued, ease of transportation and the availability of amusement parks have made the county fair a less central annual event. (Courtesy Tidewater Newspapers, Inc.)

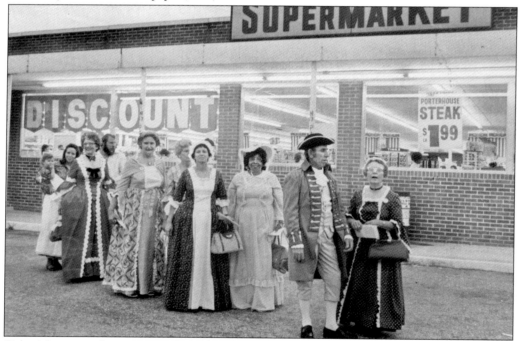

Colonial-costumed citizens march in a bicentennial-year parade. A cooking competition was held, and Mrs. Wade K. Roy's mandarin orange cake won the grand prize and first in desserts. Bertha Carter's sweet potato pie won second place, and third went to Laura Geboe's lemon meringue pie. In other categories, prize-winning entries included Sally Lunn bread, marinated carrots, crab imperial, crab dip, crab salad, banana pie, and escalloped oysters. (Courtesy Tidewater Newspapers, Inc.)

Toward the end of the 20th century, fewer Gloucester citizens were able to make a profitable living by farming or working on the water. Scenes such as this one of Brown's Bay remind us of Gloucester's traditions and rural way of life. (Courtesy Walter G. Becknell.)

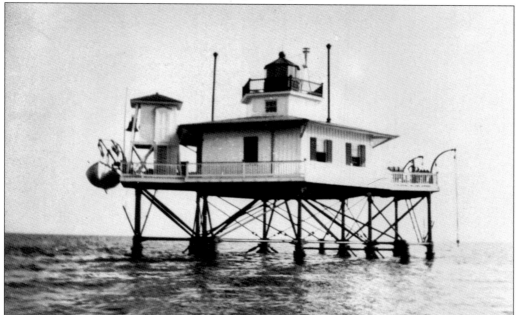

Lighthouses warned watermen and sailors off of Chesapeake Bay's sandy shoals from the early 19th to the mid-20th century. The Depression-era Virginia Writer's Project captured the memories of Gloucester lighthouse keeper Albert Lee Davis from the era before York River lighthouses such as Page's Rock, Tue Marsh, and York Spit were dismantled and replaced by electric beacons. (Courtesy F. Raymond and Mary Belle Lewis.)

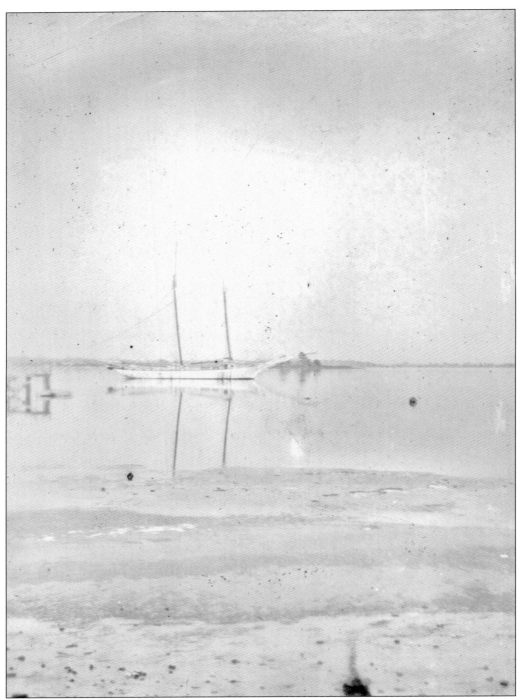

The age of photography saw steamers and motorized boats usurp the need for Chesapeake Bay log canoes, bugeyes, and skipjacks, and highways usurp the prevalence of transporting by boat. Although these means for making a living on the water are in the past, their traditions remain strong in the hearts and minds of Gloucester's people. (Courtesy William L. and Martha Ellen Brockner.)

Five

GATHERING PLACES
Landings and Crossroads

Gloucester's earliest gathering places were at the landings where ships brought goods, information, and people to isolated plantations. As early as 1674, a road existed to connect Tyndall's Point to what would become Gloucester Court House. From there, an ancient Virginia Indian road linked Gloucester Court House and the upper part of the county along the Piankatank. Another connecting line was drawn by the main road that followed the heads of York River creeks, crossed the county, intersected with the first thoroughfare, and passed by Ware and North River plantations on its way to Kingston Parish.

Water landings and crossroads became natural locations for the scattered residents of Gloucester to gather. Early taverns and ordinaries included Seawell's Ordinary, the Botetourt Hotel, Woods Ordinary, and Dragon Ordinary. At Gloucester Point, ferry keepers operated an ordinary and later a hotel.

During the industrial age, steamboats of the Chesapeake Steamship Company (York River) and the Old Dominion Line (Mobjack Bay) were the most familiar conveyances for goods and people. Service centers at landings were developed to handle mail and provide food, lodging, and entertainment.

In his autobiography, T. C. Walker recalled, "The different sections of the county were customarily indicated, not by signposts, but by crossroads that had a general store or gristmill on a corner. By such landmarks one knows when he is passing from one neighborhood into another."

Prior to the Civil War, there were post offices at Gloucester Court House, Woods Cross Roads, Glenns, Hayes Store, and Cappahosic. From the second half of the 19th century to 1920, the number grew to 10 times as many. Motorized travel over land became more common, and services formerly provided at landings increased in importance at inland crossroads. As travel sped up, the need for as many stores and post offices decreased and many were abandoned.

Gloucester's remaining country stores are a source of nostalgia and charm in the fast-growing county.

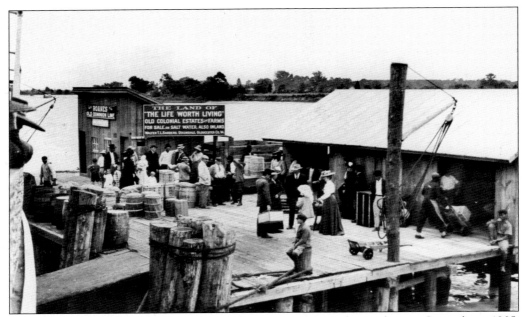

When Parke Rouse interviewed Katherine Withers Hamilton, who was born at Severnby in 1905, she recalled the days of the steamer *Mobjack*. "It was a ritual for Gloucester folk to drive down to the dock and meet the boat. At Roane's Wharf, which served us, every family had its own hitching post." (Photograph by Herman Hollerith Jr., collection of the Chesapeake Bay Maritime Museum, St. Michael's, Maryland.)

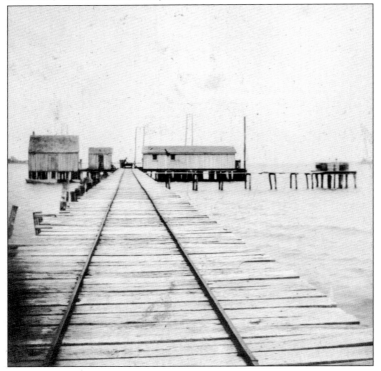

Chesapeake Steamship Company steamers used the Clay Bank pier. They connected river landings to Virginia's inland via railroads at West Point. Tracks on the pier guided the wheels of mule carts loaded with freight and luggage along the landing place. (Courtesy Bill and Madelyn Weaver.)

In Gloucester, the steamer *Mobjack* serviced landings on the North, Ware, and Severn Rivers, and the James Adams Floating Theater visited with entertainment. An Adams Express Company sign can be seen below the post office sign on a wharf building at this unidentified landing. The photograph was taken from onboard a steamer. (Courtesy Bill and Madelyn Weaver.)

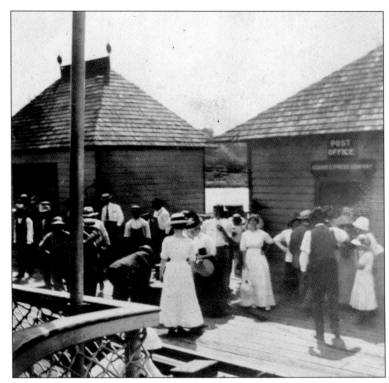

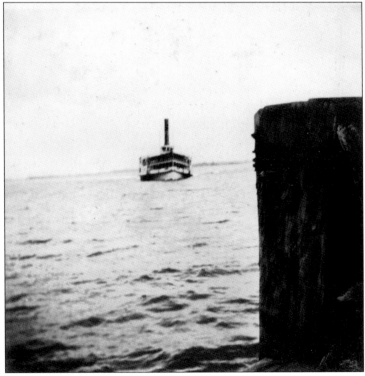

Steamers from West Point stopped at Allmond's Wharf, Clements, Clay Bank, and Gloucester Point on their way to Baltimore. Large steamboats that made the round-trip on the York River and Chesapeake Bay included the *City of Richmond*, the *City of Annapolis*, the *City of Yorktown*, and the *City of Baltimore*. (Courtesy Bill and Madelyn Weaver.)

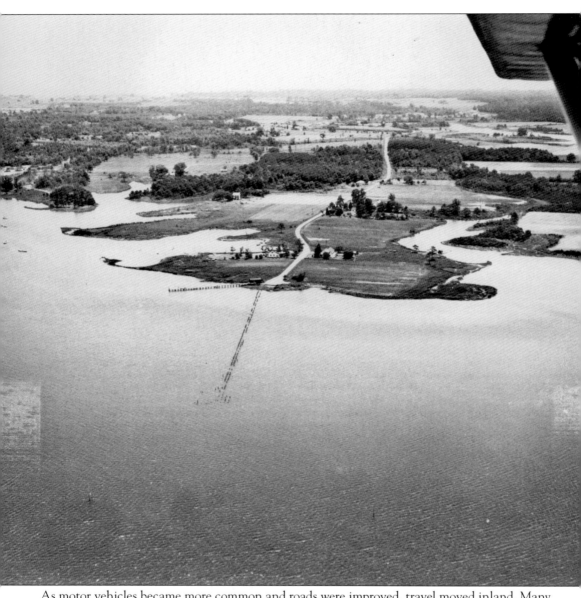

As motor vehicles became more common and roads were improved, travel moved inland. Many landing operations, such as Severn Wharf, went out of business. By the mid-20th century, when this photograph was taken, a skeleton of pilings was all that remained of the once-vibrant port. (Courtesy Walter G. Becknell.)

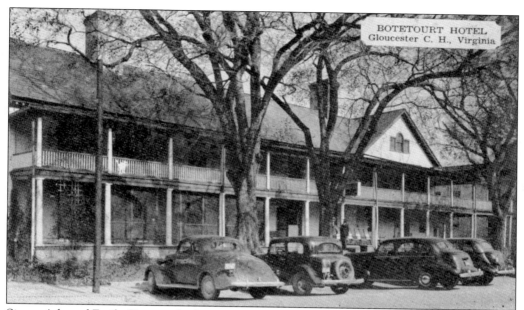

Sisters Ada and Emily Cox ran the Botetourt Hotel during the Depression years. They told their Works Progress Administration Writers' Project interviewer that the hotel had been called the Botetourt Tavern in Colonial days. Their father had run coachmaker, blacksmith, hardware, paint, and mercantile shops in Gloucester Court House. (Courtesy William S. Field.)

During the 1781 buildup to the Battle of Yorktown, American general George Weedon used Seawell's Ordinary as his headquarters. One of Virginia's earliest ordinaries, Seawell's provided shelter and meals at a point approximately halfway between Tyndall's Point and Gloucester Court House. The nearby Ordinary Post Office still serves the community. (Courtesy Library of Congress, Prints and Photographs Division, Historic American Buildings Survey, HABS VA,37-ORD,1-1.)

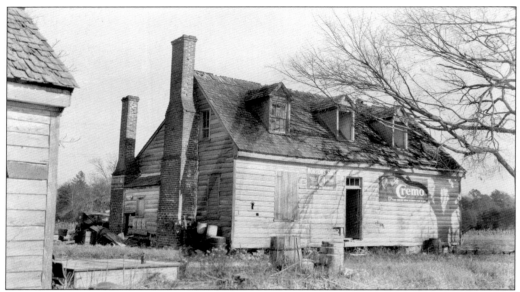

Historic surveyors took a photograph of the White Marsh store sometime after 1933. An advertising sign on the building for Cremo 5¢ cigars attests to the triumph of the industrial age as it boasts that "no Cremo is made by hand." (Courtesy Library of Congress, Prints and Photographs Division, Historic American Buildings Survey, HABS VA,37-WHIMA,2-1.)

Jeff Booth was well known for crafting and refinishing furniture in his shop behind Roane's Store. Booth's daughter, Mary Bright, remembers locals gathering to share news of the day there. She accompanied her father to the store's post office when Bernard Woodland was postmaster and recalled her wonder at letters her father received from customers in New York City, where Bright later lived and worked. (Courtesy of Mary Bright.)

Irene Morgan boarded a bus at Hayes Store in July 1944. Seated on the second row, she was asked to move to the back when white passengers got on at White Marsh. Morgan refused and was arrested in Saluda. Her case was appealed to the United States Supreme Court, where the justices decided that Morgan's conviction should be reversed. (Courtesy Library of Congress, Prints and Photographs Division, Historic American Buildings Survey, HABS VA,37-GLO,4-1.)

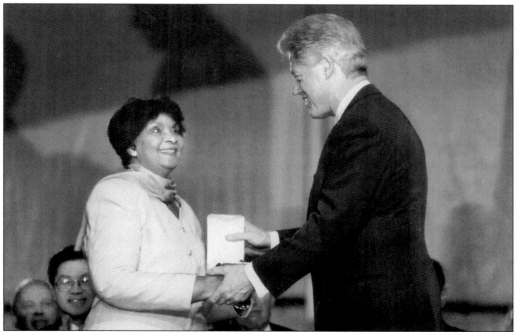

In 2001, Irene Morgan received the Citizens' Medal from Pres. Bill Clinton. She was cited for quietly and bravely testing Virginia's segregation laws by refusing to move to the back of a Greyhound bus in 1944. The landmark Supreme Court case was heard 11 years before the better-known Rosa Parks case. (Courtesy Cleo Gregory Warren.)

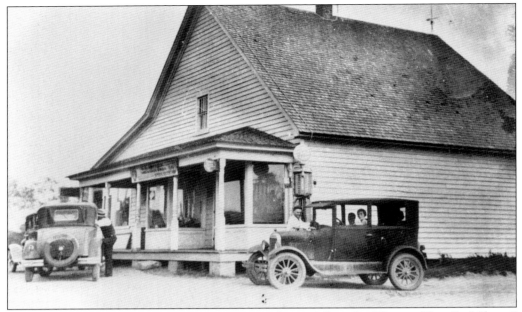

Mr. and Mrs. Jim Ashe owned the Perrin Store and Post Office, the "Home of Sun Dial Shoes." This photograph's donor, Nan Belvin McComber, remembers a ritual of her early school years was to be taken to the Ashes' store by her parents to be fitted for a new pair of Sun Dial shoes. (Courtesy Nan Belvin McComber and the Guinea Heritage Association, Inc.)

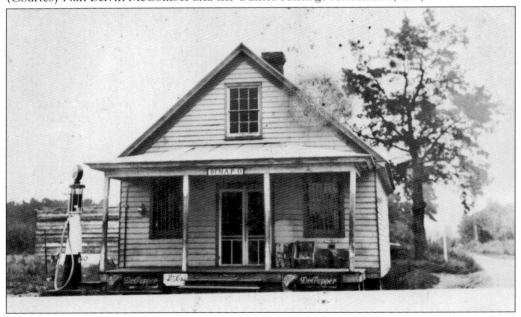

Marian Porter Clements shared this early picture of C. B. Rowe's store and post office at Bena with the *Gloucester-Mathews Gazette-Journal*. The photograph was taken before the store was moved to make way for road-paving operations that began in 1957. The store dates to the late 19th century, when the Hall brothers ran it. The store's name was changed to reflect its new ownership around 1920. (Courtesy Tidewater Newspapers, Inc.)

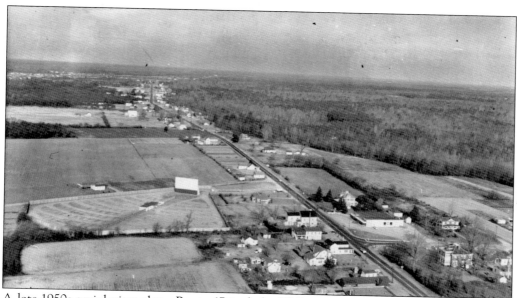

A late-1950s aerial view along Route 17 includes Williams Drive-In, one among thousands that represented a brief moment in history when a love of the automobile and fascination with Hollywood crossed paths to produce a memorable bit of Americana. Families who lived in Gloucester through the middle years of the 20th century remember gathering at the drive-in or at one of the segregated indoor movie theaters. (Courtesy Walter G. Becknell.)

The Calvin Hotel was located on Main Street in Gloucester and was a favorite place to take the family out for dinner. The Calvin Hotel and Sutton's Restaurant in Gloucester Court House were especially busy at lunchtime on Sundays after church. Crab cakes, fried chicken, and roast beef were served with mashed potatoes, stewed tomatoes, green beans, fried apples, and other home-style favorites. (Courtesy Tidewater Newspapers, Inc.)

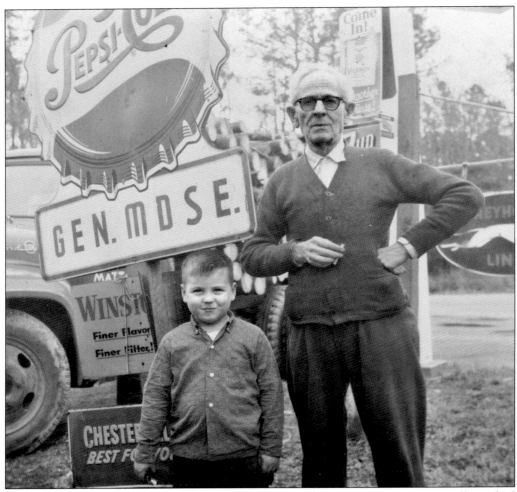

Country stores and post offices became gas stations and convenience stores as traffic picked up the pace and paved highways provided ready access to places that had once seemed distant. Originally a gas station, the Horsley Store on Route 17 housed Short Lane Post Office. C. B. Horsley is pictured in front of the store in this 1960 photograph. Signs advertising cigarettes, soft drinks, and the Greyhound bus line surround him and his grandson, Nelson Horsley Jr. A newspaper article printed that year said there were 21 independent businesses—mostly filling stations and groceries—between Gloucester Court House and Gloucester Point. Horsley, who was interviewed for the article, commented, "I don't imagine there will be any left ten years from now." Horsley was storekeeper at Roane's Store for 24 years and Short Lane for 23 years. (Courtesy Gloucester County Public Library.)

Six

COMMUNITIES FOR LIVING
Neighborhoods, Schools, Churches, Families, and Friends

In 1680, Edmund Gwyn gave six acres in Ware Parish to the people of Gloucester so that the courthouse and other public buildings would be centrally located. Later the area was named Botetourt Town for Virginia's governor, Norborne Berkeley, Baron de Botetourt, but the name fell from use after the American Revolution.

T. C. Walker said, "Strangely enough, Gloucester is not the name of a town. . . . [Gloucester] is . . . tidewater country with its flat stretches divided into plantations. . . . The county courthouse . . . is some twenty-six miles from a railroad and centers some straggling houses, a few stores, and a post office. . . . The address of the people living there and in the surrounding countryside is simply 'Gloucester Court House' or, briefly, 'Gloucester.' "

Gloucester Court House provided a place to act out the rituals of rural life—court days, parades, and banking. Although there were many rural stops throughout the county, most of the county's populace saw Gloucester Court House, with its government offices and primary businesses, as its focal point.

The community known as Guinea, although unnamed on modern maps, is Gloucester's most renowned. Watermen have historically inhabited this unique area located southeast of Gloucester Point. Some were Hessian and English soldiers who did not wish to return to Europe after fighting in the American Revolution. At one time, Guineamen formed their own subculture built around working in the seafood industry and spoke their own dialect. Their uniqueness is fading, however, as the seafood industry declines and they are absorbed into the rest of modern-day Gloucester.

Churches and schools have also defined communities for living in Gloucester. The first church community in the county was Abingdon Parish. The first free-school effort dates to the 17th century, when Henry Peasley bequeathed 600 acres to be used as a free school. Family groups and sport teams also define Gloucester's rural population. Finally the county's local newspapers have maintained independence that brands them as upholders of Gloucester's spirit and voice in an overly homogenous 21st-century landscape.

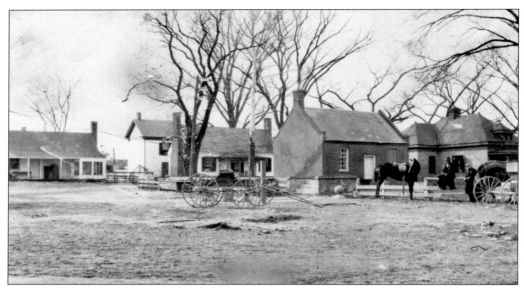

Public buildings, including the clerk's office, are seen in this undated photograph, along with drivers waiting nearby with horses and carts. John Clayton, one of Gloucester's earliest clerks, is remembered for his interest in nature and for compiling "A Catalogue of Plants, Fruits and Trees Native to Virginia." One of Clayton's sons served as a Gloucester deputy clerk, and another son was clerk of the New Kent court. (Courtesy Gloucester County Public Library.)

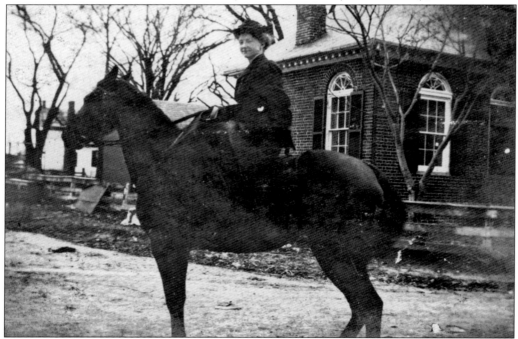

A family album includes this and other pictures of young people from Ware and North River families before a backdrop of early Gloucester government buildings. The earliest courthouse was destroyed by fire, but a second was built in 1766. It is seen behind the rider and is preserved in Gloucester's Historic Courthouse Circle today. (Courtesy William L. and Martha Ellen Brockner.)

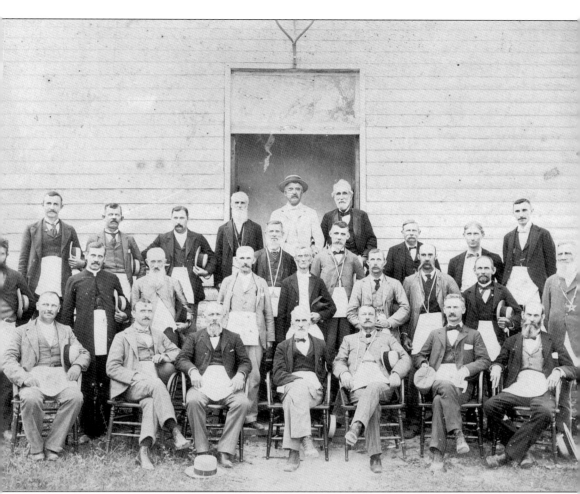

An inscription on the back of this photograph identifies Freemasons assembled at Botetourt Lodge near the courthouse as (first row) Jack Simcoe, unidentified, Warner P. Roane, William Jones, A. P. Philips, W. T. L. Taliaferro, and Alex T. Wiatt; (second row) Alonzo Pratt, Rev. William B. Lee, Willoughby Mason, Charles E. Cary, unidentified, Joshua Gray, ? Eastwood, and two unidentified; (third row) H. P. Mason, unidentified, J. D. Callis, Claiborne Roane, Fred Wolfe, two unidentified, and Thad E. DuVal; (fourth row, standing in door frame) William E. Wiatt, Adam Fitzhugh, and Gen. William B. Taliaferro. One of Gloucester's best-known figures, Taliaferro mustered out in August 1848 and commanded the Confederate troops at Gloucester Point in 1861, where the first shots of the Civil War in Virginia were fired. Later he fought in the Shenandoah Valley and Northern Virginia. General Taliaferro was a member of the Virginia General Assembly for 10 years. (Courtesy Special Collections, Earl Gregg Swem Library, College of William and Mary.)

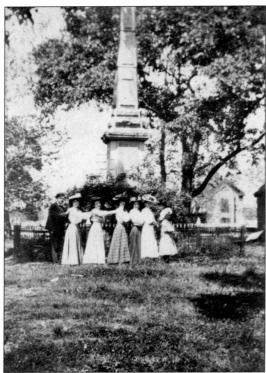

The Confederate Monument, in front of Gloucester's courthouse, was unveiled on September 18, 1889. The celebration culminated years of fund-raising events intended to memorialize soldiers and honor their families. This photograph was taken in front of the monument approximately 15 years later. (Courtesy William L. and Martha Ellen Brockner.)

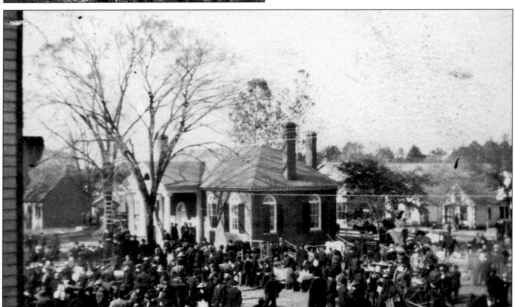

The caption below this 1907 photograph when it appeared in the *Gazette-Journal* read, "As crowds gathered around sellers of roasted oysters, patent medicines and other products, legal business is transacted in [the] Courthouse. . . . Court day . . . was a major event in Gloucester with several thousand people attending . . . to buy plows, etc. and enjoy the carnival atmosphere." (Description by Vanbibber Sanders; Courtesy William L. and Martha Ellen Brockner.)

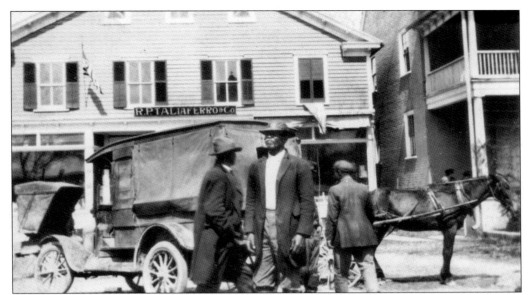

In 1855, a Richmonder was advised to sell his house near the village of Gloucester. It was presumed that the county seat would be moved to a convenient location at Cappahosic "within the next three years, and then houses in the Gloucester neighborhood will be drugs on the market." In this photograph, business was brisk at Taliaferro's Store, located between the county government buildings and the Botetourt Hotel. (Courtesy Lee Brown.)

Before the Bank of Gloucester was built on Main Street, there were about five businesses in the village around the Colonial courthouse called Gloucester Court House, including the Tidewater Telephone Company. The road was still unpaved, but electricity and telephone service were available to a few citizens. (Courtesy William L. and Martha Ellen Brockner.)

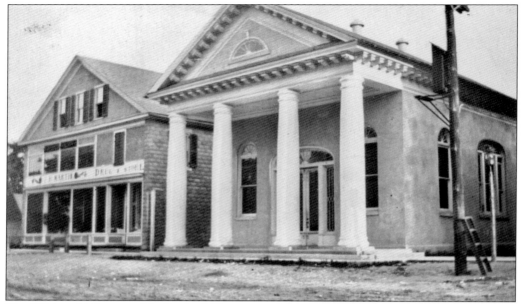

The 1906 establishment of the Bank of Gloucester solidified a business district near the courthouse. "Before there was a bank in Gloucester nobody had any way of knowing whether a man had any money," said Thomas C. Walker in *The Honey-Pod Tree*. A thrifty person "had an old sock or bag or trunk in which he kept his savings or he carried it out into the yard and buried it." (Courtesy Bill and Madelyn Weaver.)

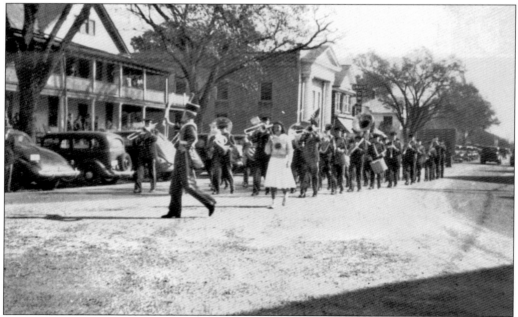

Gloucester's central village became the setting for county parades. A band performed in front of the Botetourt Hotel during this 1937 parade. Other photographs from the event show that the former Taliaferro Store is signed "H. L. Vaughn" and a newly built brick wall encircles the historic courthouse and local government buildings. (Courtesy Lee Brown.)

The first Gloucester Days was held in Gloucester Court House in 1958. Sponsored by the Gloucester Village Business Association, it included a fashion show by the Emma Jane Shoppe near Lewis Avenue. This photograph captured a moment during the fashion show when Mrs. Elsworth German, left, narrated and, from left to right, Mrs. Hattie Barnes, Ronald Clements, Joanne Lawson, Mary Temple Donner, and Carol Donner participated. (Courtesy Tidewater Newspapers, Inc.)

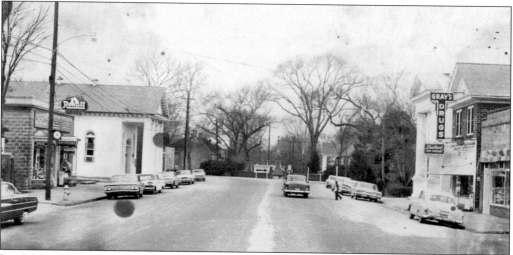

In 1965, stores on Main Street included Morgan's Drug Store and Gray's Drug Store. Gray's was operated in that location from 1925. A full-service restaurant was operated on the premises briefly, beginning in 1934. The store carried whiskey until the Virginia ABC store opened in 1954. A sandwich counter opened in the 1950s and continued to be popular until the drug store closed in 1979. (Courtesy Tidewater Newspapers, Inc.)

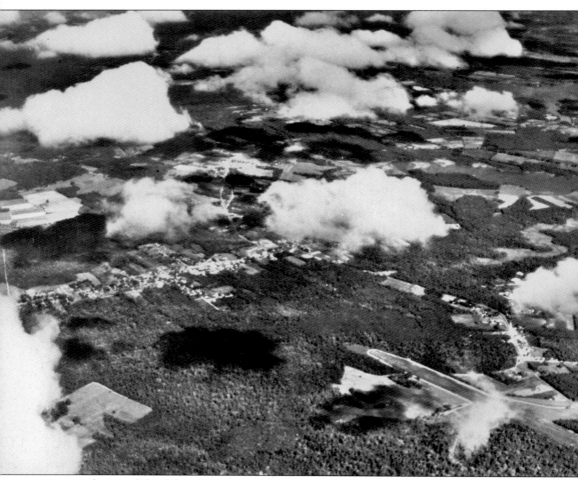

An aerial view of the Court House community was taken around 1960. The view is toward the north, and the Ware River can be seen in the photograph toward the east. The scene recalls 18th-century traveler Durand de Dauphine's comment that "Nature had delighted in giving to this land many useful charms, one of them being that at various points the sea extends into the land small inlets of a hundred and fifty to two hundred feet wide. Some extend in half a league." The Gloucester Country Club is visible in the lower left-hand portion of the photograph. Abundant tree cover is otherwise interrupted by the airport, roads from Gloucester Point and toward Mathews, and cultivated fields. (Courtesy Walter G. Becknell.)

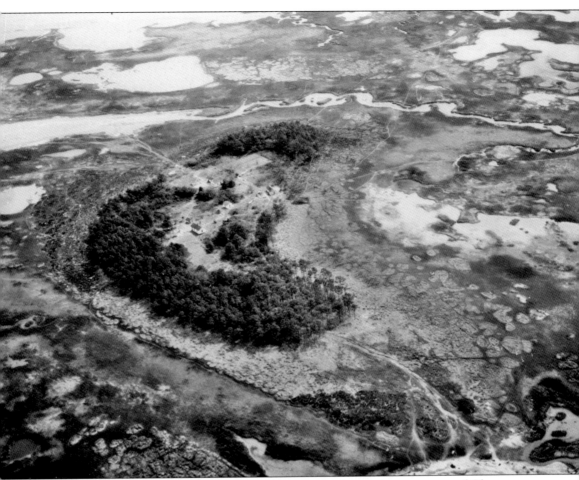

In 1653, Edward Dobson received a patent for 950 acres in the southeastern part of Gloucester. Later he acquired additional land to include most of the area known today as Guinea—Achilles, Severn, Maryus, Perrin, and Bena. Up to the Civil War, the Dobson family was influential, but afterwards, like most of Virginia's prominent families, they suffered financially. Homes and farms could not be sustained without slave labor. Portions of the property were sold, but it wasn't until 1874 that the Perrins mortgaged what was left of their Guinea Plantation to Joel and Achilles Rowe. The name Guinea may have developed due to the fact that slaves from Guinea in West Africa were brought to the area on several occasions in the early 18th century. The easternmost reach is called Big Island, pictured in this *c.* 1960 aerial view, and was home to a clan of Guineamen who lived an independent life there until the mid-20th century, when few resources on the island and the lure of modern conveniences on the mainland made their future implausible. (Courtesy Walter G. Becknell.)

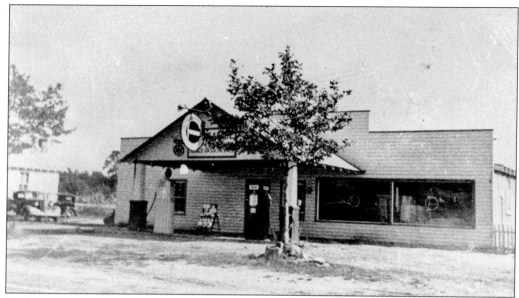

In the 1930s, the Pointer brothers built an automobile mechanic's garage in Bena. It became Carlyle Brown Sr.'s Studebaker dealership in the 1940s, and Gloucester High School auto mechanics classes were taught there later. During the 1970s, while it housed John Smith's alignment business, local musicians converted the showroom into a music hall called "Gasoline Alley." The building was given to the Guinea Heritage Association for storage of memorabilia. (Courtesy Nan Belvin McComber and the Guinea Heritage Association, Inc.)

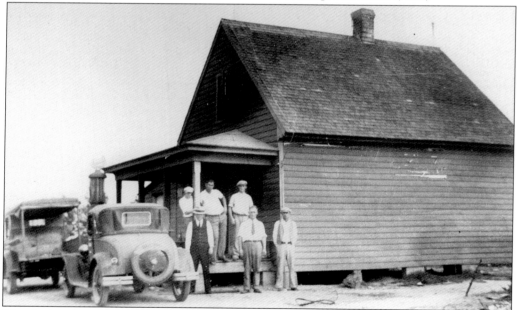

John Jenkins's store at Maryus in the far end of Guinea, seen in this *c.* 1930 photograph, was a gathering place for local watermen and farmers and their families. Large families and few surnames are two of the characteristics that have made the Guinea community unique and close-knit. (Courtesy Nan Belvin McComber and the Guinea Heritage Association, Inc.)

Photographed about 1930, Nannie Butler Belvin was one of eight children of Tom and Gracie Jenkins Butler. Nannie married her brother-in-law Joe Belvin, after her younger sister Martha Ellen died in childbirth. Three of Nannie's eight children married Bonniville siblings. Two couples moved into their Belvin parents' home, situated on almost 48 acres of marshy shore along John West's Creek and Brown's Bay. (Courtesy Nan Belvin McComber.)

Luther (left) and Carter Smith (right) visit with Luther's brother-in-law, Frank Via Belvin Sr., in this 1944 photograph. The Smith family moved to Middlesex after their home flooded during the August Storm of 1933. Afterwards they visited relatives at the Belvin home place often. The extended family supported themselves by oystering and clamming and raising crops and livestock. Although the Belvin farm was divided in 2005, their descendants continued to live on one part of it. (Courtesy Nan Belvin McComber.)

The idea for a Guinea Jubilee arose during a conversation at the Plaza Pharmacy soda fountain. The founders wanted to celebrate and preserve an appreciation for their unique heritage. They invited the community to join in, and the response has made the jubilee a success for several decades. Ninety-one-year-old retired waterman Henion Brown served as the grand marshal of the 1983 Guinea Jubilee. (Courtesy Tidewater Newspapers, Inc.)

The Guinea Jubilee's parade began as a course through the parking lot in front of Plaza Pharmacy. It has grown, and today's route leads through "downtown" Guinea (Bena). In 1992, the Abingdon Ruritan Club float featuring a giant clam won second place. (Courtesy Tidewater Newspapers, Inc.)

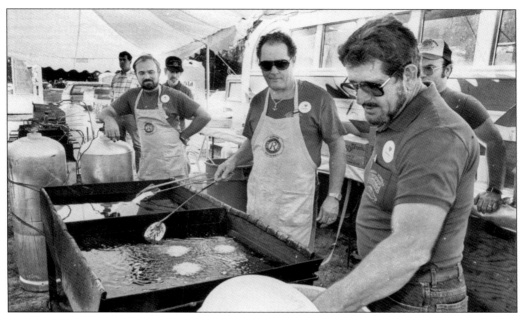

Since the earliest jubilee, clam fritters have been a favorite. Abingdon Ruritan Club members Mark Tackett (left), John Beck (center), and L. T. Wells (right) prepare fritters at the 12th annual event. The shallow water off of Gloucester's shores historically has allowed the Chesapeake's world-famous oysters and clams to thrive. Disease and murky waters have weakened the once-healthy environment for shellfish, compounding the impact of centuries of heavy harvesting. (Courtesy Tidewater Newspapers, Inc.)

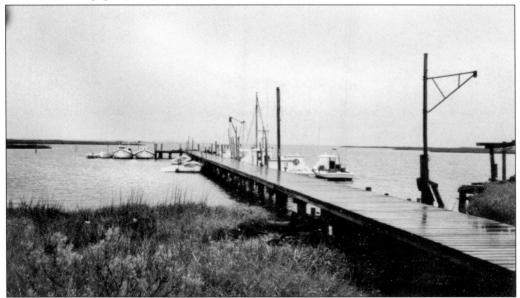

The workboats of the proud and strong individuals who once dominated the area symbolize the spirit of Guinea. As early as the mid-20th century, fewer resources meant fewer boats docked at Guinea wharves. Today some have been pulled out of the water and into the marsh, left to fade with our memories of the rich tradition of the Guineaman. (Courtesy Walter G. Becknell.)

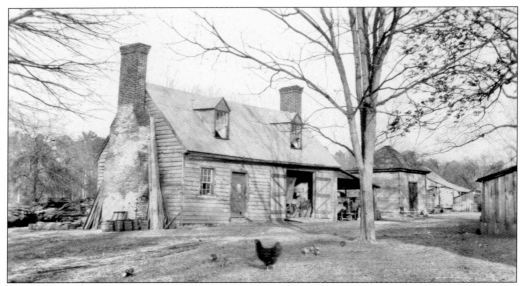

When Virginia began to assert public education rules, John Tabb of Summerville opened a private school called Gloucester Academy. An inscription on this photograph from Frank L. Kerns for Frank Weaver reads: "The half of this house next to you was 'Gloucester Academy.' Mr. John Tabb was your and my teacher. . . . Some young men he prepared to enter the University of Virginia." (Courtesy Bill and Madelyn Weaver.)

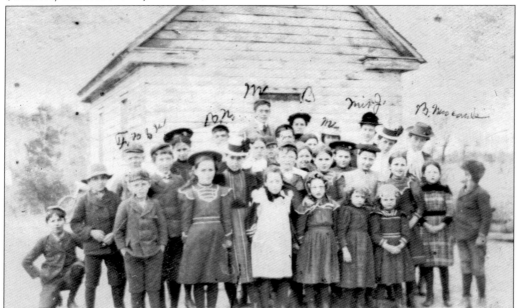

Virginia law required counties to have public schools by 1876. In 1892, there were 53 public schools in Gloucester with 975 whites in 25 schools and 1,627 blacks in 28 schools. This 1900 photograph at Sassafrass School includes Martin Pointer, Blanche Shackelford, Bob Newcomb, Augustine Trevillian, Pearle Trevillian Hart, Floyd Walker, Sam Newcomb, Eugie Sheppard, Winnie Sheppard, Beulah Newcomb Weaver, Effie Walker Nicholas, Florence Trevillian Martin, and teacher Mattie Jayne. (Courtesy Tidewater Newspapers, Inc.)

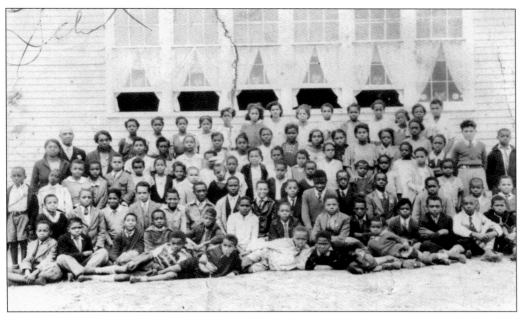

Few resources were available to African Americans in the early years of public education. T. C. Walker and W. B. Weaver championed Cappahosic Academy, funded by the American Missionary Society between 1891 and 1933. After the Great Depression, funding declined, and the school was closed in the 1930s. More than 70 students attended Bethel School in 1935. It was established with private funds and was later conveyed to the county. (Courtesy Dr. Dorothy Cooke.)

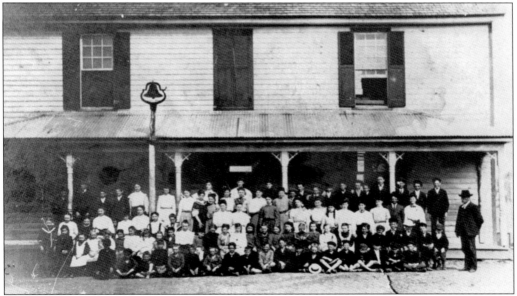

An Achilles teacher remembered entering the first grade in 1892 when Achilles school was held in a log cabin. This 1904 photograph shows the building after a second story was added. In 1910, two large rooms were added to the front of the building, one upstairs and one downstairs. The school that had formerly ended instruction at grade seven graduated its first high school class of three ladies in 1914. (Courtesy Nan Belvin McComber and the Guinea Heritage Association, Inc.)

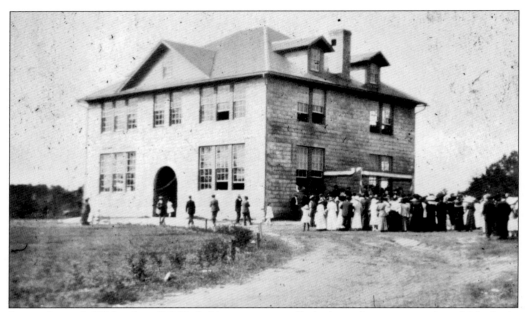

It wasn't until 1908, when 3,949 children were enrolled, that whites outnumbered blacks in Gloucester's public schools. The newly built Botetourt High School was one of 21 schools in the county for whites. There were 19 schools for blacks. This photograph of Botetourt from a family album is of a gathering at the school that may be a dedication event. (Courtesy William L. and Martha Ellen Brockner.)

At Botetourt, May Day celebrations welcomed spring with maypole dances and the coronation of a queen, as seen in this *c.* 1915 photograph. By mid-century, the ritual faded due to its association with worker rebellion and socialism. Labor Day replaced May Day as a business-friendly celebration of the American worker. In Gloucester schools, athletic field days and Earth Day became springtime rituals. (Courtesy Bill and Madelyn Weaver.)

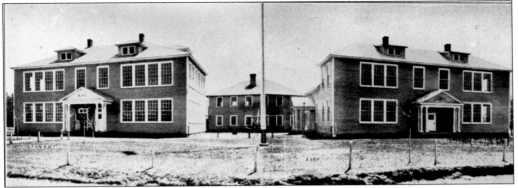

The cornerstone for a larger Achilles school for 1st- through 11th-grade students was laid in June 1920. Four years later, another building was constructed. The last class of 23 students graduated from Achilles High School in 1952. In that year, Botetourt and Achilles High Schools were consolidated. In 1966, a modern building replaced the former Achilles building, which had continued to be used as an elementary school. (Courtesy William S. Field.)

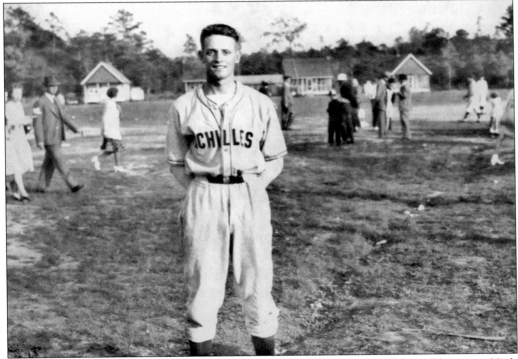

Ashby Turner Walthall played baseball for Achilles and then graduated from Gloucester High School in 1961. In basketball, he averaged 28.7 points a game as a senior and finished his career with 1,470 points, a Gloucester school record. Walthall also was the Gloucester quarterback in football and shortstop in baseball. After high school, Walthall attended Virginia Tech. (Courtesy Tidewater Newspapers, Inc.)

Although the same board administered schools for whites and blacks, T. C. Walker met "persistent opposition." When the black high school was established, it was named "Gloucester Training School, rather than High School, due to the prejudice of some," said Walker. Other photographs of early schools can be seen in the Jackson Davis Collection of African American Educational Photographs at the University of Virginia. (Courtesy Tidewater Newspapers, Inc.)

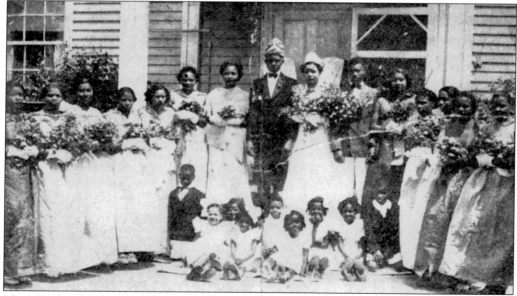

Mary Bright was crowned May Queen during 1940 ceremonies at Gloucester Training School. Standing are, from left to right, Christine Cochin, Doris Booth, Louise Hodges, Mary Carter, Mattie Drummond, Lucille Stokes, Eleanora Davenport, Robert Morris (King), Mary Booth (Queen) Van Smith, Eunice Gregory, Lillian Davenport, Helen Phillips, Almay Stokes, and Mattie Hawes. The seated children include Robert Smith, Delories Goodridge, Ann Carter, Etta Woodhull, Georgiana Smith, and James Robinson. (Courtesy Mary Bright.)

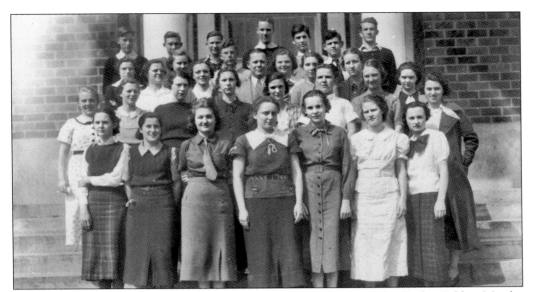

Botetourt's class of 1937 included from left to right, (first row) Verna Soles, Evelyn Selden, Martha Beth Newcomb, Bessie Abernathy, Evelyn Byrd Hutcheson, Kate Oliver, and Mary Thrift; (second row) Eliza Nuttall, Esther Wroten, Louise Teagle, Ruth Haynes, Helen Moore, Dorothy Deal, Elizabeth Teagle, and Mary Lee Roane; (third row) Hester Wolffe, Rebecca Wolffe, Louise Trevillian, Dorothy Minter, Lee Rhodes, principal D. D. Forrest, Murryal Groh, Countess Bristow, and Hazel Figg; (fourth row) Bob Selden, Charles Edwards, Edwin Robins, Dick Lawrence, Joe Atkins, Foster Leigh, and Ellsworth Jenkins. (Courtesy Tidewater Newspapers, Inc.)

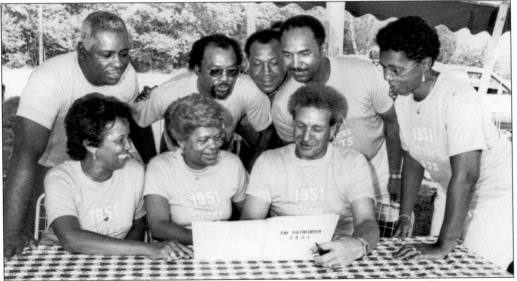

In 1986, the Gloucester Training School class of 1951 reunited for the first time in 35 years at the Moton Conference Center in Cappahosic. Reminiscing with their yearbook are from left to right (seated) Elaine Moore Washington, Helen E. Lockley, and Robert Lemon; (standing) Irving Carter, Hersey Foster, William Harris, Franklin Ross, and Jean Washington. In the 1950s, T. C. Walker School was built to accommodate African American students from throughout Gloucester County. (Courtesy Tidewater Newspapers, Inc.)

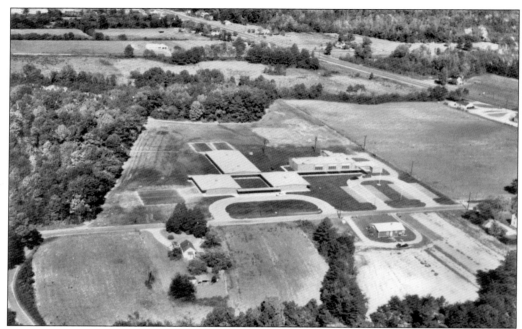

Abingdon Elementary School was new when this aerial view was taken about 1960. The flat-roofed school plan replaced the earlier two-story cube plan, as seen at early Botetourt, Achilles, and Gloucester Training Schools. The new style was believed to be more intimate than the former rooms with their seven-foot-high blackboards. (Courtesy Walter G. Becknell.)

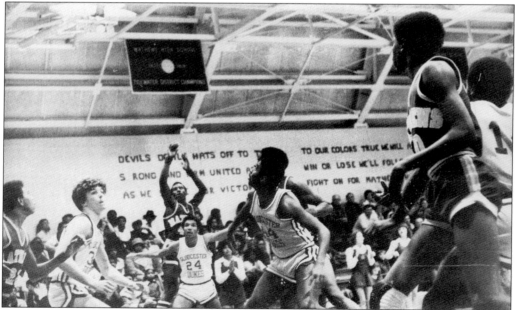

Mathews County was founded in 1791 and included Gloucester's former Kingston Parish area. As sister counties, ties were close and school rivalry was friendly though keen. Sports match-ups, as seen in this 1979 photograph from the files of the *Gloucester-Mathews Gazette-Journal*, were well attended. Gloucester won this basketball game 68-63. (Courtesy Tidewater Newspapers, Inc.)

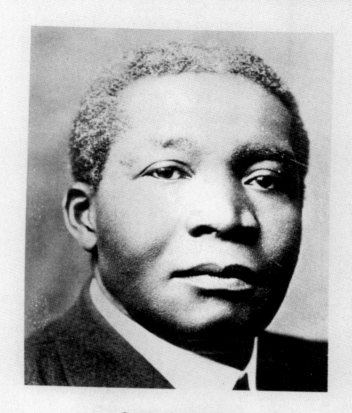

A Tribute to

Robert Russa Moton

Second President 1915 - 1935

President Emeritus 1935 - 1940

1867 - 1940

Virginia-born Hampton Institute graduate Robert Russa Moton was the second president of Tuskegee Institute in Alabama. His second wife was Jennie Dee Booth of Gloucester, and they retired to Gloucester County to build their home, Holly Knoll. Moton brought some of the most prominent authorities of the day to Cappahosic to discuss topics such as housing, education, and civil rights. His home later became known as the Moton Conference Center. The United Negro College Fund was conceived there, and it is said that Dr. Martin Luther King drafted his "I Have a Dream" speech on a bench under a 400-year-old oak on the property. Recently a diary believed written in the hand of Jenny Dee Booth Moton was discovered. It described the world trip that the couple took in 1926 and included photographs, postcards, steamship passenger lists, and newspaper articles reporting on Moton's visits. (Courtesy Mary Bright.)

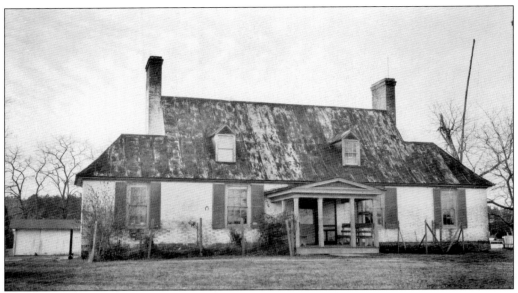

When Virginia was still a British colony, the church organization gave structure to the community. Abingdon Glebe came into existence in 1674 as a home farm in support of the cleric of Abingdon Parish. The house, located on land between Abingdon and Ware parishes, was built around 1700. (Courtesy Library of Congress, Prints and Photographs Division, Historic American Buildings Survey, HABS VA,37-WHIMA,1-3.)

Although the first Abingdon Parish church was located nearby, the present church building was not constructed until 1755. Members of the parish included the first families of Gloucester: Burwell, Cary, Catlett, Clark, Dixon, Lewis, Page, Perrin, Seawell, Selden, Sinclair, Tabb, Taylor, Todd, Warner, Whiting, and others. (Courtesy Library of Congress, Prints and Photographs Division, Historic American Buildings Survey, HABS VA,37-WHIMA,1-3.)

Ware Parish was formed about 1656, and the first church building was located on the road to Ware Neck. The present church was built in 1715. In 1847, a Tabb relative wrote, "On the 25th we attended church. . . . The church itself is quite a curiosity. . . . After the services were over, we all assembled in front of the building and such a shaking of hands you never witnessed." Troops used the structure during the American Revolution and the Civil War. Like Abingdon, Methodist congregations gathered there until it was repaired and revitalized as a place of worship for Protestant Episcopalians. Nearly 1,000 gravestones in the churchyard mark the final resting place of prominent citizens, including Thomas Todd, a 17th-century settler, and many of his Tabb family descendants. Confederate general William Booth Taliaferro is buried in the Ware cemetery. (Courtesy Library of Congress, Prints and Photographs Division, Historic American Buildings Survey, HABS VA,37-GLO.V,2-2.)

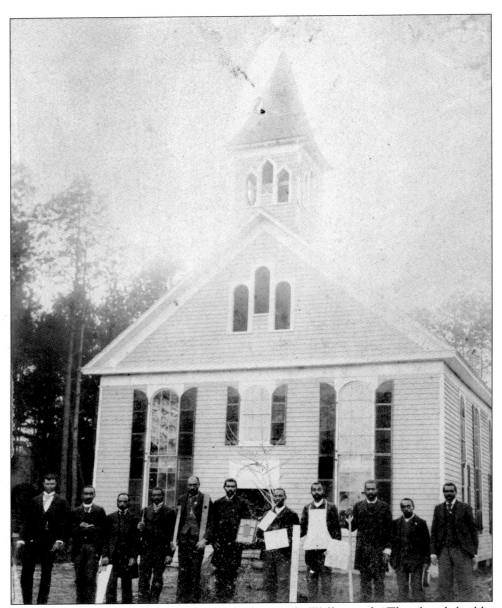

Remembering African American churches, Thomas C. Walker said, "The church buildings were so broken down and poor. . . . Our own church . . . was an unsightly, ramshackle place. . . . The church leaders became agreed that a remodeling program should begin. . . . Before many weeks had passed, the broken down old Sassafras Stage church had taken a new lease on life. . . . Even its name was improved. It was called Bethel Baptist church and grew until it had a large congregation. . . . There is not a single log-cabin type church left in the county. Instead of the seven tumble-down buildings of my boyhood days, there are now fourteen well-built Baptist churches." The 1889 Bethel Baptist Church dedication was attended by, from left to right, Robert T. Drummond, James C. Lemon, A. J. H. Reed, Harrison Selden, George Leigh, Rev. J. W. Booth, Thomas Walker Sr., Johnny Baytop, George Yates Jr., Peter Bolden, and Harrison Palmer. (Courtesy of Bethel Baptist Church.)

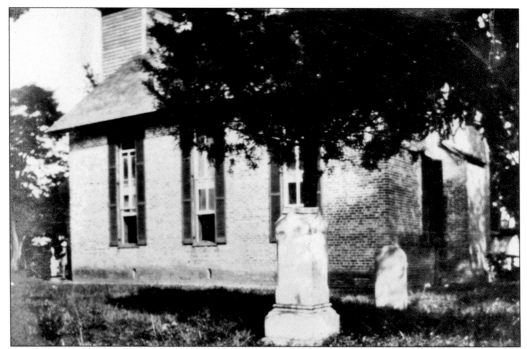

White Baptists established their first church in Gloucester in the Petsworth area around 1790 and others were formed shortly thereafter. In 1795, Bellamy Methodist, pictured above, and Mount Zion Methodist Churches were founded. Eighteenth-century bishop Francis Asbury was instrumental in founding the church. After the Civil War, a Presbyterian congregation was established in Gloucester Court House. (Courtesy Bill and Madelyn Weaver.)

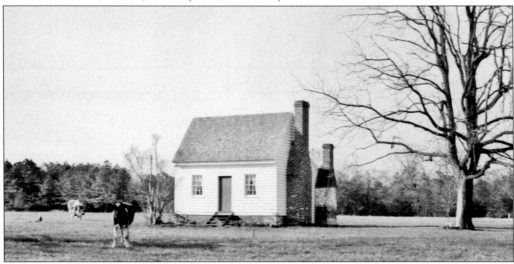

While a parsonage was being built for the Gloucester circuit of the Methodist Church, Rev. Lemuel Sutton Reed and his family lived in this cottage, where Dr. Walter Reed was born in 1851. Dr. Reed led a commission to Cuba to study the cause of yellow fever. The discovery that mosquitoes transmitted the disease led to a cure. (Courtesy Library of Congress, Prints and Photographs Division, Historic American Buildings Survey, HABS VA,37-BEL,1-2.)

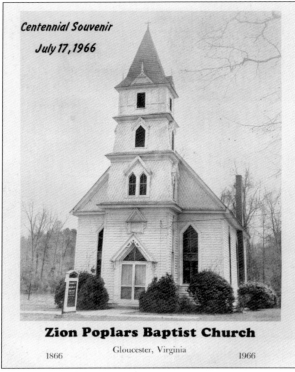

Centennial Souvenir
July 17, 1966

Zion Poplars Baptist Church
Gloucester, Virginia
1866 1966

A congregation that founded Zion Poplars Church met to celebrate their African Baptist traditions in a grove where seven poplar trees were united in a single trunk. The present church was built in 1894 and is on the National Register of Historic Places and the Virginia Landmark Register. (Courtesy Mary Bright.)

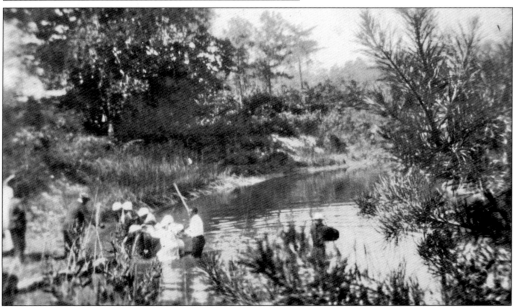

As late as the 1950s, outdoor baptism was common in both black and white Protestant churches. The natural setting for this important rite of passage enhanced its symbolic association with purification and initiation. River baptism followed the Biblical example of Christ's baptism in the Jordan River by John the Baptist and his urging his followers to preserve this tradition. (Courtesy William L. and Martha Ellen Brockner.)

In the 1940s, Union Baptist Church on Guinea Road purchased a bus to transport area residents to church. As seen in this c. 1950 photograph, it brought children to vacation Bible school whose fathers were watermen and mothers did not drive. Once there, children learned the books of the Bible and were rewarded with a Bible embossed with their names. The church was founded in 1801 in a small building heated by an open fireplace. Before the Civil War, part of its membership was black, led by a separate board of deacons. The Civil War brought disorder: after April 1861, nearly all able-bodied men joined the Confederate army, and Pastor William E. Wiatt became chaplain of the 26th Virginia Infantry. Expanded in 1844 and remodeled in 1869 and 1884, by 1948, Union Baptist Church was the largest rural Baptist church in Virginia with a membership of over 900 people. The church in this photograph was replaced by a larger building in 1958 that continues to be an important hub of community activity and source of pride. (Courtesy Nan Belvin McComber.)

Extended families who lived close together characterized early Gloucester. With the advent of the car, many enjoyed touring in their automobiles in spite of the fact that few roads were paved until the 1930s. Some roadways were made more stable by the use of rafts of long, straight tree trunks. These so-called "corduroy roads" were bumpy but preferable to the chances of becoming stuck in the mud. (Courtesy William L. and Martha Ellen Brockner.)

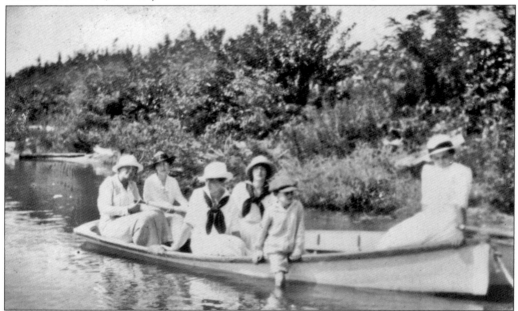

Young ladies and a little boy enjoy visiting and a Sunday drive Gloucester-style—a slow float along one of its many tidal creeks. The white, flowing dresses represent fashion before World War I, when an idealized Gibson-girl look was still preferred. After the war, women's dresses with straight lines and dark colors suited the more sober point in time. (Courtesy Bill and Madelyn Weaver.)

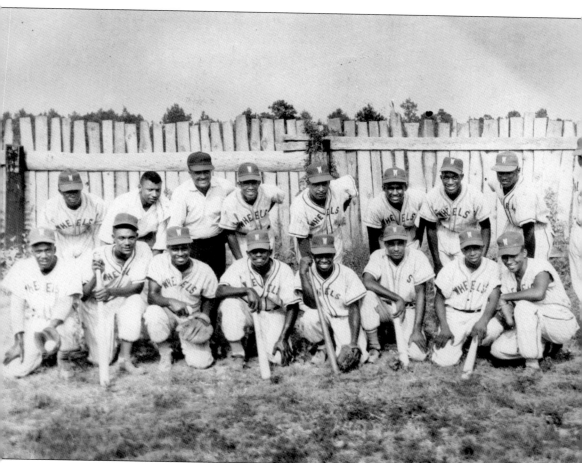

African American entrepreneur Leon Gregory (third from left, standing), a 1936 graduate of Gloucester Training School, sponsored the Wheels baseball team that included, from left to right, (kneeling) Weldon Foster, Phillip Tabb, George Gregory Jr., Ike Green, Ceasar Wilson, Bushey Combs, Willie Lewis, and Lawrence Saunders; (standing) Pernell Lee, Willie Carter, Gregory, Robert Stokes, Harold Stokes, Pete Stokes, Ben Marvel, Lynwood Cooke, and Earnest Wilson. In 1948, Gregory started a softball team for young ladies called the Spokes. Gregory is best remembered for the Wagon Wheel tavern, which opened on Guinea Road in 1941 and moved to a larger building on Route 17 in 1944. The Wagon Wheel had pool tables, a counter and booths, jukebox, bandstand, and dance floor. Many well-known entertainers, including Otis Redding, Fats Domino, James Brown, Tina Turner, and the Coasters, visited the establishment. "I remember going there as a child. I worked in the kitchen and met all the stars," said Cleo Gregory Warren. "That was my world." In 1948, Leon Gregory opened the Hub Cleaners and partnered with George Catlett and George Gregory to open the Rim Theatre. (Courtesy Cleo Gregory Warren.)

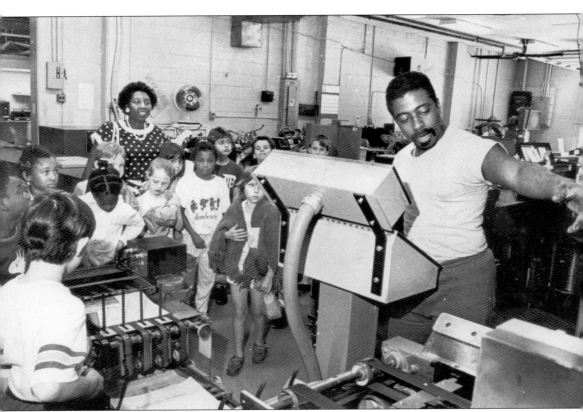

The printed word has been an outlet for Gloucester's community voice since the late 17th century, when records reveal that a printing press was probably located in Gloucester. William Nuthead, a servant indentured to John Buckner, Gloucester County clerk of court, apparently printed a document without permission from the government. The records of Buckner's interrogation have led historians to believe that the first printing press in the Virginia colony was operated in Gloucester. Through the 18th and a portion of the 19th century, Williamsburg's *Virginia Gazette* served the needs of Gloucester citizens. Late in the 19th century, local newspapers included the *Gloucester Herald*, the *Tidewater Liberal*, and the *Gloucester Mail*. A 20th-century newspaper was *The News Reporter*. The *Mathews Gazette* dates to 1905, and the *Gloucester Gazette* started in 1919. They merged in 1937 to form the *Gloucester-Mathews Gazette-Journal* under the corporate name Tidewater Newspapers, Inc. In this 1980s photograph, *Gloucester-Mathews Gazette-Journal* pressman Bobby Dixon explained newspaper printing to Gwyn Lee's second-grade class from Botetourt Elementary School. The tabloid *Glo-Quips: Magazine of Gloucester* has provided another venue for community conversation since the 1960s. (Courtesy Tidewater Newspapers, Inc.)

Seven

LIFE-ALTERING EVENTS
Wars and Cars

World War I shook Gloucester from its Reconstruction-era slumber and touched off the modern era. While hundreds of Gloucester men joined the army, navy, merchant marines, and Red Cross, the greater Hampton Roads area boomed with military bases and the shipbuilding industry drew more people to the area. Never before had so many people traveled . . . or traveled so far. One of the deadly results was the flu pandemic of 1918.

As transportation increased, more cars poured onto the landscape. With cars came the need for better roads, stations to sell gasoline, and mechanics to service motors. Whole new industries were created while older ways changed. Steamers were a less and less popular means of transportation. Local blacksmiths were no longer essential. The number of country stores decreased, and the distance between them increased as cars and trucks moved between them.

Nearly three times as many Gloucester men were involved in World War II as in World War I. Afterward the opportunity to work further away from home increased. Within a generation, the Gloucester Point car ferry was outmoded and replaced by a bridge. Agriculture was no longer the county's leading occupation.

Shellfish disease and concern about damage to the susceptible coastal environment led to the establishment of the Virginia Fisheries Laboratory in 1940. Land was purchased to build in Gloucester Point in 1950, and a facility was built and renamed the Virginia Institute of Marine Science (VIMS) in the 1960s. A branch of the College of William and Mary, VIMS is one of the top marine science research and educational facilities in the world.

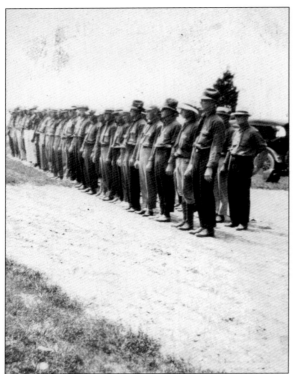

Just after 1900, when 40 men met in the courthouse to form a military unit, Gloucester, like the rest of the South, was still struggling economically and socially. Segregation was entrenched, and many blacks and whites had left the county to find opportunities elsewhere. Between 1910 and 1920, the county's population dropped by approximately 25 percent. (Courtesy William L. and Martha Ellen Brockner.)

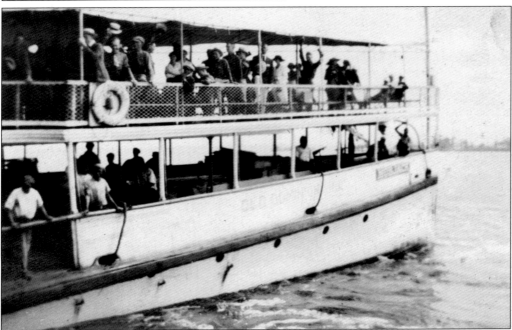

In the spring of 1917, many Gloucester and Mathews men boarded the steamer *Mobjack* at Hockley Wharf to join the war effort. In 1917, 298 Gloucester men joined the military and the U.S. Merchant Marines. (Courtesy William L. and Martha Ellen Brockner.)

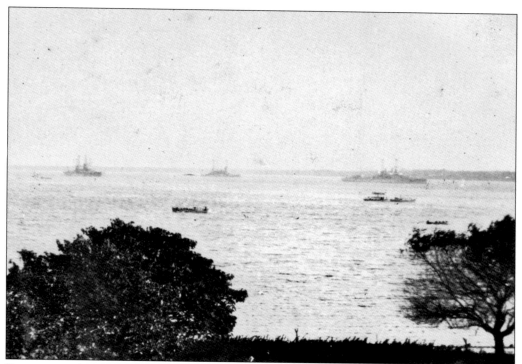

From various locations along Gloucester's shores, navy ships could be seen practicing maneuvers in the York River and Mobjack Bay. During the mining of the North Sea to prevent German submarines from using it to access the Atlantic, Yorktown was selected as the location of a plant for storing, assembling, loading, testing, and issuing the mines. (Courtesy William L. and Martha Ellen Brockner.)

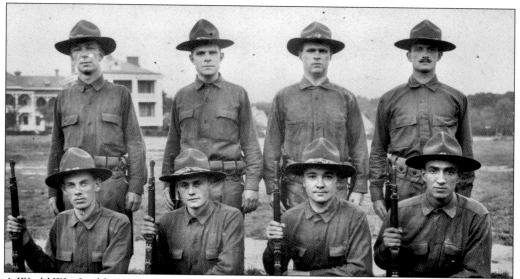

A World War I soldier sent this picture postcard to Mrs. D. P. Sanders at Gloucester Court House from Fort Myer in September 1917. The sender wrote, "Why don't you and Van write me sometimes . . . Jack." (Courtesy William L. and Martha Ellen Brockner.)

Gloucester visitors board a World War I navy ship. According to Mary Wiatt Gray in her 1936 book *Gloucester County*, "Gloucester Point was an amazingly busy place. . . . A great many of the United States battle ships were in Hampton Roads and many of them in the York River. There were thousands of sailors . . . almost a solid mass of them in white or blue." (Courtesy William L. and Martha Ellen Brockner.)

The message that the Kaiser had decided to abdicate reached the American lines on November 9, 1918. Gloucester celebrated the end of "the war to end all wars" with a parade through Court House. The scale of destruction during World War I eclipsed all previous wars. New technologies such as airplanes, tanks, and submarines made the war longer and harder to win while inflicting more casualties. (Courtesy William L. and Martha Ellen Brockner.)

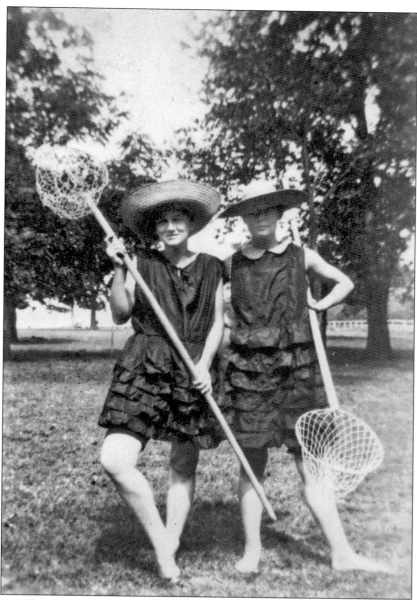

The Roaring Twenties visited Gloucester, too. The years between the world wars have been remembered for a naughty rebelliousness that was exemplified by "flappers," fun-loving women known for their shocking behavior. While Gloucester's "dip net ladies" may not look scandalous today, exposed knees and short hair were emblematic of a new age for women. In the 1920s, more women were working outside the home and enjoying labor- and time-saving devices like sewing machines and washing machines. Other important events of the years between the wars, such as Prohibition and the Great Depression, were felt less in rural areas like Gloucester due to the independence that most families still enjoyed. But the tide of modernism was rising in Gloucester as surely as the floodwaters of the August Storm of 1933. Broad social, political, and natural events picked up speed and washed over Gloucester as well. (Courtesy William L. and Martha Ellen Brockner.)

More than 800 Gloucester men enlisted in the military during World War II, and many others joined the U.S. Merchant Marine. William Booth was stationed in Germany. The war was large and deadly, characterized by aerial bombing and genocide that would mark all who lived through its upheaval. (Courtesy Mary Bright.)

In 1986, Woodrow W. James of Dutton recalled his World War II experience while showing a *Gloucester-Mathews Gazette-Journal* reporter his license plate. His 29th Division stormed Omaha Beach on June 6, 1944. He wrote of the Statue of Liberty, which he passed first in 1942, that "the meaning of what she stands for had been written in blood upon the minds of many of us." (Courtesy Tidewater Newspapers, Inc.)

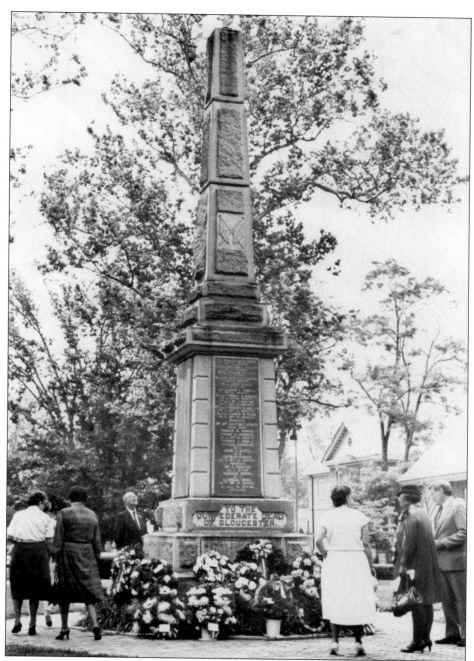

The Confederate Monument, erected to honor Gloucester's Confederate dead, is the focal point of Memorial Day services. It was not until after World War I that Southerners recognized the last Monday in May as a national holiday to honor those who had died in wars. Memorial Day services in the Historic Court Circle, such as this one held on May 29, 1986, commemorate Gloucester men and women who have lost their lives in the Civil War, the Spanish-American War, the world wars, and conflicts in Korea, Vietnam, and the Persian Gulf. (Courtesy Tidewater Newspapers, Inc.)

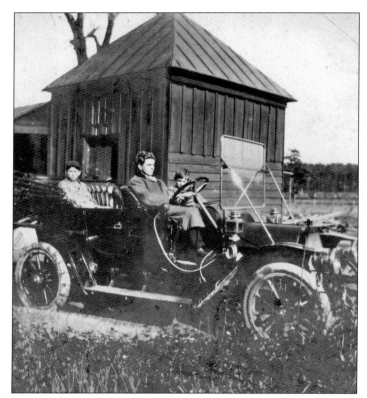

At first, automobiles were viewed with suspicion. Without good roads, automobiles provided little more than an opportunity for amusement. Lawyer T. C. Walker said, "While the automobile in itself is a great institution . . . it teaches many people to spend what they haven't got. . . . The automobile . . . is responsible for focusing attention outside of the home rather than in it." (Courtesy William L. and Martha Ellen Brockner.)

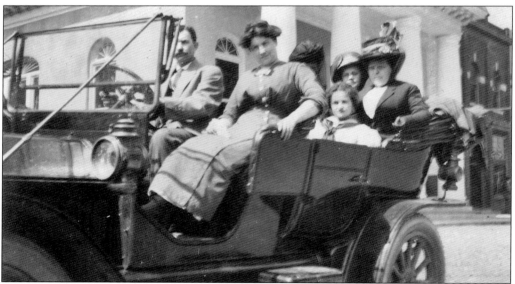

Automobiles caused people to travel more often, following inland roads that no longer tied to water routes. On the back of this photograph, Frank L. Kerns wrote: "All aboard for 'Eagle Point.' Mr. Frank Weaver gives Mrs. Bunny Kerns, Mrs. Nora Vaden, little Connie Kerns and Mr. and Mrs. Frank Kerns a sightseeing trip in his new automobile—one of the first cars brought to Gloucester County." (Courtesy Bill and Madelyn Weaver.)

In 1918, William T. Ashe had Willis T. Smith of Achilles build the *Cornwallis*, a ferry large enough to carry cars, for $15,000. As interest in Jamestown, Williamsburg, and Yorktown increased, travelers from the North used ferries to cross the Piankatank and followed unmarked roads through Gloucester. Later Route 17 provided a thoroughfare. Robbins Hotel at Gloucester Point and the Monument Lodge at Yorktown provided accommodations for travelers. (Courtesy William L. and Martha Ellen Brockner.)

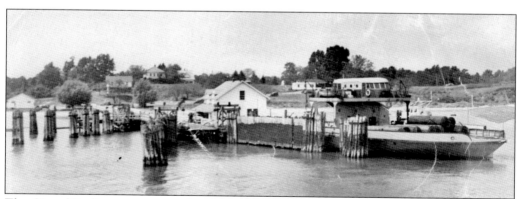

The *City of Burlington* was moved to Gloucester in 1942 and overhauled to become the ferry *Virginia*. In the 1940s, a one-way trip for car and driver cost 55¢; a round-trip fare was 80¢. Walk-on passengers traveled for 15¢. With Sam Belvin as captain, the *Virginia* made its last trip across the York River on May 7, 1952, at noon. (Courtesy C. David Burke.)

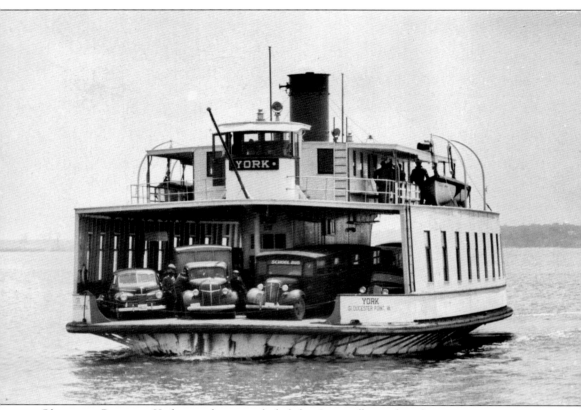

Gloucester Point–to–Yorktown ferries included the *Cornwallis*, *York*, *Palmetto*, *Miss Washington*, *Gloucester*, and *Virginia*. The *York*, pictured here, was put into service in 1925 and ran until 1952. The Ferry Corporation was sold to the Virginia Department of Highways in 1951 for $785,646. (Courtesy C. David Burke.)

A 1957 aerial view of Bena provides a glimpse of the rural area when Guinea Road was still lightly traveled and much land was cultivated. The First Morning Star Baptist Church can be seen in the bottom right. C. B. Rowe's store is in the center. (Courtesy Walter G. Becknell.)

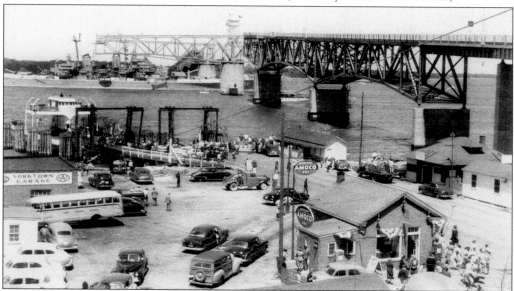

This view of the George P. Coleman Bridge, named for the state's second highway commissioner, was taken from Yorktown looking toward Gloucester Point. On May 7, 1952, the USS *Macon* cut ribbons suspended from the spans to become the first vessel to pass through. Earlier that day, the river ferries returned to their slips at Gloucester Point, ending a centuries-old practice. School buses provided transportation for Gloucester residents to the festivities. (Courtesy Nan Belvin McComber.)

Although Gloucester's Route 17 road was refurbished as a four-lane highway about 1960, it was lightly traveled by today's standards. The county would not get its first traffic light until the mid-1970s. This aerial view was taken over Ordinary. Providence Road is perpendicular to the main highway. (Courtesy Walter G. Becknell.)

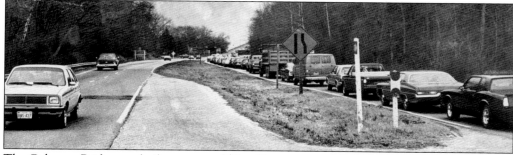

The Coleman Bridge was built at a cost of $9 million to accommodate 15,000 cars a day. Because of the bottleneck caused by the steady increase in traffic, as seen in this 1985 photograph, a new four-lane bridge with a capacity of 30,000 cars opened in 1996. The cost of reconstruction was $76.8 million. A toll, removed in the 1970s, was reestablished. (Courtesy Tidewater Newspapers, Inc.)

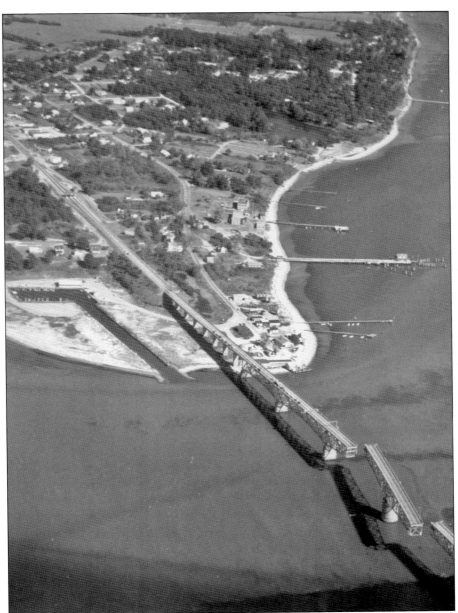

The 3,750-foot-long, double-swing-span Coleman Bridge, seen here in about 1960, is the largest of its kind in the United States. The movable span is needed to allow ships to access several military installations that are upstream. The roadways are almost 90 feet above the river at the highest point of the bridge. The two main river piers contain mechanisms that lift the swing spans to different heights so they do not hit each other as they rotate. When the new bridge was constructed in 1996, it was floated in six complete sections—pavement, light poles, and barrier walls—over 40 miles from Norfolk, Virginia, to the bridge site. This marked the first time in engineering history that such a large bridge was assembled off site and floated into place. The new four-lane bridge is three times wider than the original bridge but weighs 25 percent less because the new bridge is made of lightweight, high-strength steel. (Courtesy Walter G. Becknell.)

In 1960, the new Virginia Institute of Marine Science complex included some of the largest buildings in Gloucester County. Following the county government and public school system, it would become Gloucester's largest employer. Today the Institute conducts interdisciplinary research in coastal ocean and estuarine science, educates students and citizens, and provides advisory service to policy makers, industry, and the public. (Courtesy Tidewater Newspapers, Inc.)

Researchers at the Virginia Institute of Marine Science and elsewhere noticed a relationship between certain chemicals and the decline of bald eagle and osprey. DDT caused birds, like this one photographed in Gloucester around 1950, to lay eggs with extremely fragile shells. The thin shells usually broke, and chicks were killed during incubation. After DDT was banned in 1972, the birds began to reproduce successfully again. (Courtesy Walter G. Becknell.)

The rockfish, or striped bass, has been one of Gloucester's most popular game fish. Pollution and over-fishing nearly wiped them out, but conservation helped rockfish rebound and it was heralded as a success story. Today a bacterial infection plagues the fish and may be a sign that conservation alone is not enough to protect species in the Chesapeake Bay because of the long-term impact of pollution. (Courtesy C. David Burke.)

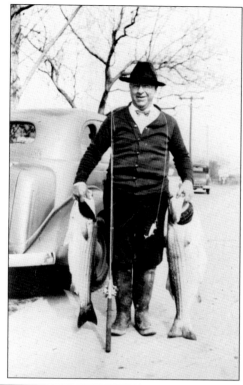

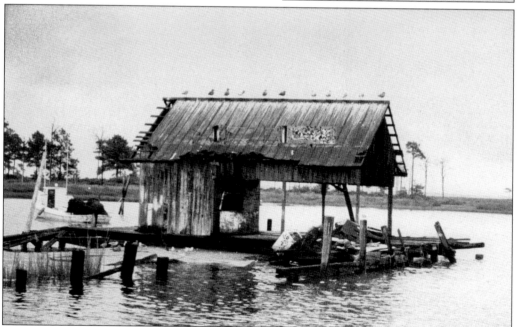

This photograph of a boathouse at Brown's Bay was taken nearly 50 years ago. The nostalgic scene conjures memories of plentiful seafood and workboats and a lively steamboat landing trade. In 2003, Hurricane Isabel erased the remnants of this effect. (Courtesy Walter G. Becknell.)

Another 50-year-old scene captures livestock grazing at Hutchinson Farm on Belroi Road. The farm was subdivided into homebuilding lots approximately 10 years after this photograph was taken. (Courtesy Virginia Tech Digital Library and Archives, AGR4576.)

Eight

LIVING UP TO A LEGACY

When she entered the College of William and Mary in 1973, the author fulfilled her freshman writing seminar assignment with an essay on a Gloucester topic: Rosewell. In 2005, her nephew, Mark Dutton, completed a similar assignment at James Madison University by writing about his parents, grandparents, and great-grandparents, who were or are all from the area. To be sure, they are not the only ones to be inspired to write about their legacy.

For all of its beautiful and not so beautiful past, and for all of its challenging yet hopeful future, pride, love, and concern for the county are heartfelt. Gloucester's heritage is a treasured possession.

Of his home—its troubles and its hopes and their relationship to all time—T. C. Walker wrote:

> Near my home, and not far from the courthouse, stood the honey-pod tree that shaded the old slave block for many years before the Civil War. Whenever there were public sales of Negroes they were assembled under this tree and auctioned off to the highest bidder. I have often been told how many of my early relatives were sold on this spot.
>
> After the Civil War the Negroes would gather under this tree on Emancipation Day and hear the Proclamation read from the old slave block. . . . All the . . . ex-slaves would join in with tears running down their faces. Later on it was decided to destroy the old honey-pod tree so a road could be straightened. . . . I opposed such action. . . . It was . . . a landmark of historical significance. . . .
>
> When young people bring me their troubles . . . I let my mind run back over the many conflicts in my own long life and the lessons they have taught me. I am still taking part in conflicts and am well aware of young honey-pod trees, but nevertheless my conviction has constantly deepened that good will is the one solution . . . to which the coming leaders must dedicate themselves in the great human race that includes us all.

During the 1976 celebration of the nation's bicentennial and the county's 325th anniversary, children perform Native American dances in commemoration of this land that became known as Gloucester. Individuals who claim a mix of African American and Native American ancestry dot the county today. (Courtesy Tidewater Newspapers, Inc.)

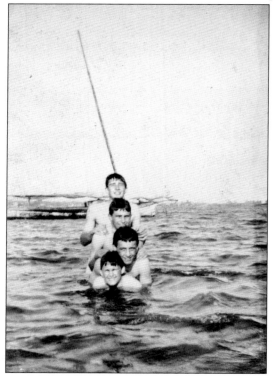

Gloucester's watery edge provided food, a highway, and enjoyment for generations of inhabitants, from Virginia Indians to early tobacco farmers to later families and friends. In this c. 1900 photograph, a log canoe is anchored behind youngsters playing in the river and hamming it up for the camera. (Courtesy William L. and Martha Ellen Brockner.)

Before World War II, most Gloucester children lived on farms and enjoyed time outdoors. From left to right in this c. 1910 photograph, John Willis, William Daniel, and Susie Mae, and John Willis Weaver pose in front of their home, Woodberry, from their pony cart. Of growing up with farmers and watermen, Nan Belvin McComber said, "Grandpa Joe Frank wanted us to be known for honesty and generosity." (Courtesy Bill and Madelyn Weaver.)

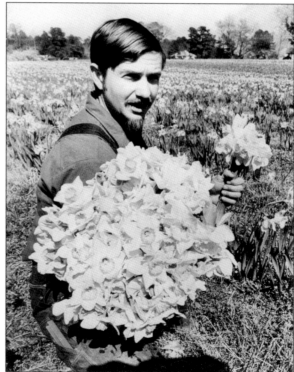

Brent Heath learned to love nature growing up on a daffodil farm. Later he directed a nature camp but eventually returned to his family's farm. Brent and his wife, Becky, enjoy a home on the water. Their Daffodil Mart is a popular Gloucester business and tourist attraction. Brent's entrepreneur grandfather's gold mine stocks may have become worthless, but the county inherited from him a wealth of golden hues. (Courtesy Brent and Becky Heath.)

Lori Rhodes (left) and Shannon Hogg model commemorative shirts for the 1982 Guinea Jubilee. Both been-heres and come-heres alike know exactly what is meant by the boast, "When I grow up, I want to be a Guineaman." Guinea is not a place; it has become a proud, Gloucester state of mind. About his love of growing up in Gloucester, Mark Dutton wrote, "My roots are deep. . . . I love the land, the water, and the rural lifestyle. . . . [I] hunt, fish, enjoy the water. . . . Those who have touched my life through church, school, and community are an extended part of my family. Just as the county motto says, it is 'the land of the life worth living.' " Growing up in Gloucester means knowing what truly makes life worth living: pride in family, history, and community, and passion for Gloucester's awesome coastal environment. It is up to the children of Gloucester to hold on to this distinctive wealth, to handle it with care, and to pass it on. (Courtesy Tidewater Newspapers, Inc.)

BIBLIOGRAPHY

Farrar, Emmie Ferguson. *Old Virginia Houses: The Mobjack Bay Country*. New York: Bonanza Books, 1955.

Foster, Adam. Letter dated January 12, 1847.

Freeman, Douglas Southall. *R. E. Lee: A Biography*. New York: Charles Scribner's Sons, 1934.

Gray, Mary Wiatt. *Gloucester County (Virginia)*. Richmond: Cottrell and Cooke Inc., 1936.

McCartney, Martha W. *With Reverence for the Past: Gloucester County, Virginia*. Richmond: Dietz Press, 2001.

Rouse, Parke Jr. *Along Virginia's Golden Shores*. Richmond: Dietz Press, 1994.

Smith, John. *A Map of Virginia. With a Description of the Countrey, the Commodities, People, Government and Religion*. Indianapolis: The Bobbs-Merrill Company, 1970.

Taliaferro, William B. "A Few Things about Our County." *William and Mary Quarterly*, Vol. 3, No. 1 (July 1894), pp. 19–27.

Walker, Thomas C. *The Honey-Pod Tree: The Life Story of Thomas Calhoun Walker*. New York: The John Day Company, 1958.

ACROSS AMERICA, PEOPLE ARE DISCOVERING SOMETHING WONDERFUL. *THEIR HERITAGE.*

Arcadia Publishing is the leading local history publisher in the United States. With more than 3,000 titles in print and hundreds of new titles released every year, Arcadia has extensive specialized experience chronicling the history of communities and celebrating America's hidden stories, bringing to life the people, places, and events from the past. To discover the history of other communities across the nation, please visit:

www.arcadiapublishing.com

Customized search tools allow you to find regional history books about the town where you grew up, the cities where your friends and family live, the town where your parents met, or even that retirement spot you've been dreaming about.